* 1st, and MOST importantly, my selection _____ ed en the <u>foreward</u>. Note on the front cover, it states "foreward by Sir Elton John & David Furnish" Wouldn't that make you want to purchase this book?

* 2ND, The name "Power of the Polaroid" intimated it was likely a picture book as opposed to 372 pages of text to read. <u>SOLD</u>! Right?

* 3rd, I assumed the book would be <u>loaded</u> with Pictures of our Superstar, Sir Elton.

~ you be the judge on 1, 2, and 3.
 You decide if this played out, as planned... or not.

 Definitely, need to schedule coffee talk to work through this equation, together!

Happy 68th Birthday!
I love you, a Very Lot!

~ Love, Punky

The Power of the Polaroid
Instantly Forever

This book is dedicated to
Charlie,
Ed,
Christiana,
Tatiana,
Walter,
Charles,
Marina
and Lily.

The Power of the Polaroid
Instantly Forever

Jo Hambro

Foreword by Sir Elton John & David Furnish

CLEARVIEW

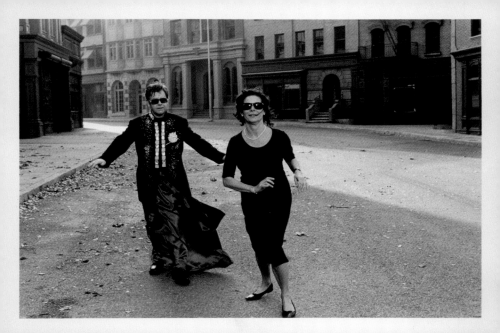

Contents

Foreword

Foreword by
David Furnish and Sir Elton John

Elton and I used to play a game where we would thumb through the latest issue of GQ then cover up the styling credits and guess which photo shoot had been overseen by Jo's exquisite eye. We'd almost always spot her beautiful work in every issue. As Creative Director at GQ for 24 years, her layouts stood apart because of their sophisticated yet timeless quality. As GQ men are fairly traditional in their tastes, Jo managed to update the clothing, sneaking in some of the most contemporary styles by paying homage to the past in the her pictorial themes and inspirations.

The first time we worked with Jo did not prepare us for the whoosh of energy when she wafted through the front door of our house in the South of France. The photoshoot was to showcase Richard James's designs, which Elton and I were huge admirers of, but it was Jo's enthusiasm and passion for her work that made such an impression on us and a fast friendship quickly ensued. Jo encouraged me to join British GQ as a Contributing Editor, and she and I remain great friends to this day.

We began to attend the men's runway collections together, and that was when my fashion education truly began. Sensibly perched and ramrod straight on the edge of her seat, I'd marvel watching Jo's razor-sharp eagle eye clocking every line and minute detail which she would often scribble down in her notebook. Afterwards she would dash from showroom to showroom, with me flying along in her wake, as she took precise note of everything that had caught her attention. "You have to feel the clothing" she would opine, "You have to see it up close to appreciate the magic." Her fine eye for detail was greatly appreciated by the designers, who welcomed her with open arms.

Looking through the pages of this wonderful book you will be able to celebrate how Jo's perfectionist approach has refined her photographic oeuvre. Jo began her career long before digitization, sourcing her ideas from books, film and art. Her preparation methods are revealed through the use of moodboards, notebooks and interviews with each photographer before the work began. The polaroids taken as each shot was set up came to define the atmosphere that Jo and the photographer were aiming to create, so that anyone who is interested in styling, photography and fashion will learn at the hands of a true and passionate expert.

Claus: 47 97 07 SS

Marlton Classics

Clothings — Oil Refining - Milano

Denim jacket

buff leather detail

buff waistcoat

| Nautical Sailing | T-Shirts Shorts. | Burgundy/Navy - Sailing - Jackets |

Chunky Sweater
Suits brown - shot - terracotta
Scarves
ting — new pants

The Douglas Brot

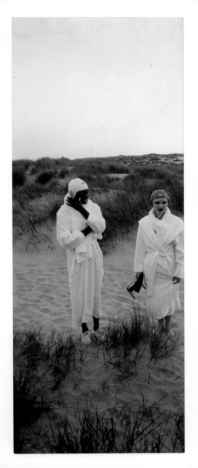

Camber Sands

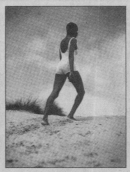
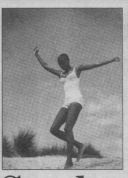
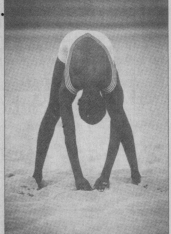

Deauville on Camber Sands

When the sexual climate is as cool as the English one, swimsuits cover more up, says Lisa Armstrong

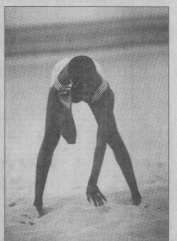

As a result of its intimate, yet strangely public nature, no other item of clothing is more instructive about our shifting mores and changing notions of beauty than the bathing suit. Compared with all those embarrassingly skimpy mono-kinis that blighted beaches during the Seventies — when letting it all hang out seemed to be the closest many people came to taking any physical exercise — Nineties swimwear is an altogether more dignified construct. Padded at the top and clenched in at the waist, today's bathing suits amount to aquatic versions of Dior's New Look, reflecting not just the traditional ideals of femininity seeping though the rest of fashion but the sensibilities of a generation that has become more wary of sex.

Geoffrey Beene, one of the most respected and inventive of American designers, believes that the swimsuit is the most modern piece of clothing in existence, "because it marries function and comfort with a highly developed sense of aesthetic beauty". For the past 10 years he has used the stretch one-piece as the starting point for all his designs. Donna Karan is another designer who has founded a clothing empire on the versatility of the swimsuit. Her unitards, which differ from bathing costumes only in that they have poppers under the crutch and come in a gamut of luxurious fabrics, from cashmere to stretchy gold leaf, have become the basis of the Karan wardrobe. It is a concept that has been widely copied and expanded upon, thanks to an astonishing range of stretch materials. The catsuits, cycling shorts and tubular Lycra micro-dresses that have dominated fashion for the past few seasons are fundamentally amplified versions of the swimsuit.

Yet it was not until the emancipation of women in the Twenties that practical, relatively lightweight swimwear was taken seriously. For the first time in

PHOTOGRAPHER: THE DOUGLAS BROTHERS (Andrew & Stuart Douglas)
DATE: 21 MAY 1991
STORY: DEAUVILLE ON CAMBER SANDS

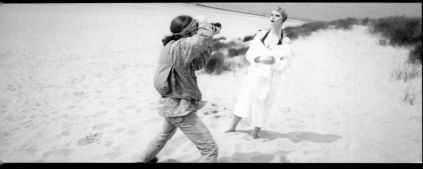

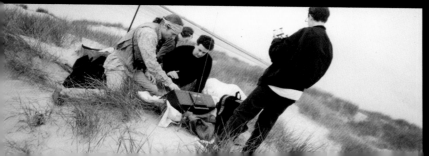

Jo: This shoot was a turning point for me creativel For the first time in my career I knew that the visio I'd had in my head had been realised in the way I' imagined it. After this I understood that working wit the right people, who had the same cinematic ey that I did, and whose references informing their wor went beyond fashion, had to be the way forwar for me.

Stuart: By this stage, having been working as a du for a couple of years, Andrew and I had honed ou modus operandi. Fashion was a perfect foil for ou skillset, allowing a fluid, impressionistic version of stills shoot to grow. The fact that there were two c us was still something of a novelty back then, an it allowed the tension of a shoot to be disperse quickly and for a huge element of fun to tak its place.

Date of shoot: 23 May '91 Swimwear
Photographis: The Douglas Brothers
Make-up: Lucie Llewellyn
Location: Camber.
Models - Lonnie Pistrite - Models 1 - Elaine Thorxi - Storm

Shot 1
Lonnie - grey - Quant - swimsuit - pale blue
Speedo - polo cap.
while Towelly robe: next.

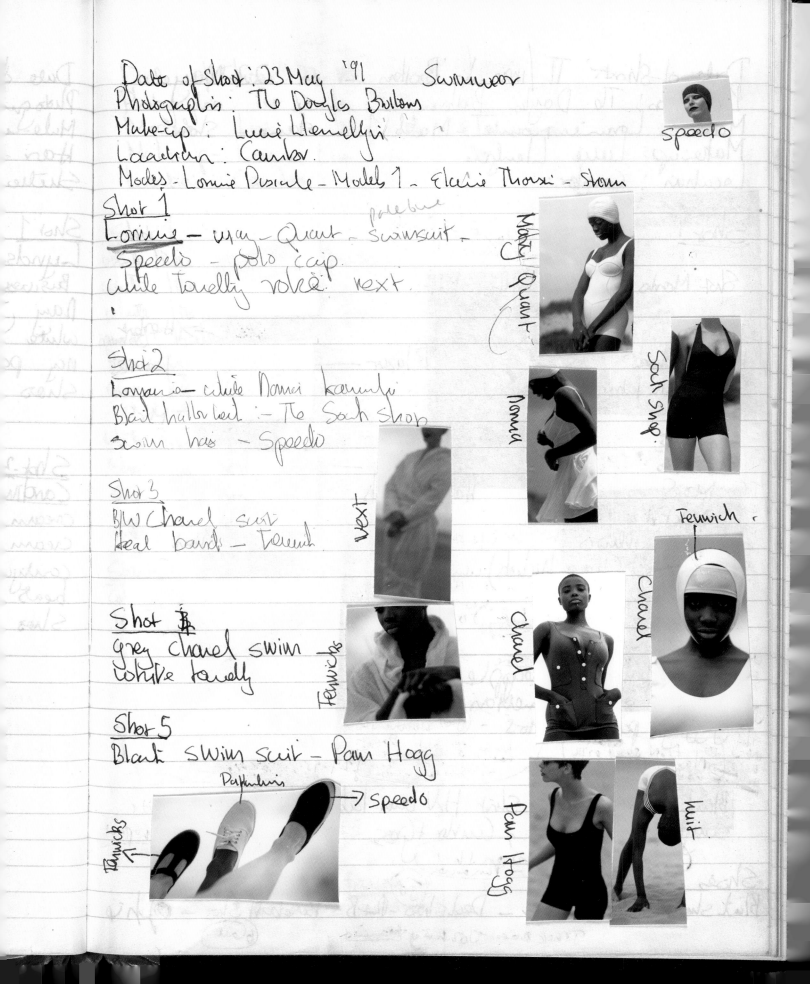

speedo

Marky Quant

Sock Shop.

Nonna

next

Fenwich.

Chanel

Chanel

Pam Hogg

huit.

Shot 2
Lonnie - while Nonna kamila
Black halterneck - The Sock Shop
swim hat - Speedo

Shot 3
B/W Chanel suit
Head bands - Fenwich

Shot 4
grey chanel swim
white towelly

Shot 5
Black swim suit - Pam Hogg
Paplanins → speedo
Fenwicks

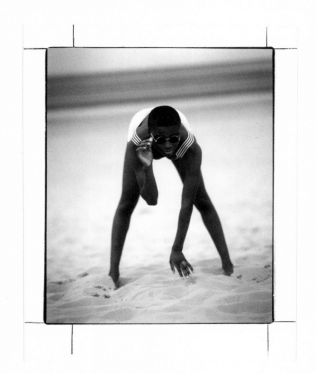

Stuart: This was a perfect collaboration with Jo, who wanted to 'play', who wanted to see what happened, who was willing and enthusiastic about experimentation. Andrew and I would seamlessly swap cameras, interchange roles as a point of focus, and generally set an atmosphere conducive to a stylized verité.

Andrew: We were not fashion photographers, although I had certainly apprenticed with many coming up, but we had a kind of reportage sensibility which Liz Jobey, the editor then of the Independent magazine, thought would mesh nicely with Jo's ideas. We created scenes rather than shots, in which things were allowed to happen, and we followed that developing scene with two cameras. This suited Jo's style of work because she also traded in ideas and moods rather than individual garments.

Jo: What I had in mind for this swimwear shoot was, as Andrew says, the atmosphere of the Parisian Riviera from 1910 to 1940: Deauville in *The Great Gatsby* was where Tom and Daisy Buchanan went on their honeymoon. Its proximity to Paris made it the holiday destination for Parisian high society, and was the birthplace of Chanel's career in fashion. I selected a lot of

Chanel-inspired clothing for the shoot to make reference to that.

Stuart: Jo always looked at projects with us as a little like theatre - these are the characters, this is the story that these clothes are telling, let's go perform. She always knew where she wanted to be, and was happy to work with us to find the best way to achieve that in a way that was not prescriptive, but collaborative and instinctive.

Andrew: Creatively, Jo's aesthetic came out of cinema and history; cinema, largely the Italian New Wave of Rossellini, Visconti and Zefferelli, and historically she was drawn to high points of elegance - from the Cote d'Azur to Newport, Rhode island, from Anna Magnani to Jack Kennedy. Jo explores her nostalgia for another more beautiful, more elegant, time. This project illustrates, for example, a story called 'Deauville' which echoes in its clothes and tone the young and beautiful at play in a 30s 40s Western France resort. This was the era when female emancipation began to influence what women wore, bringing greater freedom of movement, not only through a more relaxed cut but introducing swimwear and leisurewear as well.

Jo: Camber Sands in East Sussex was the right location, it shares the same topography as the coastline of Northern France... one of our models was Lorraine Pascale, now the famous food writer and television presenter.

Stuart: The unique moment of this particular shoot was Jo's request that Andrew and I should take our role further, and become part of the theatre, not just the documenters. To that end, and bizarre to think back to this, we were styled and wardrobed as we worked, in a variety of all white garments - oversized and overplayed, as it was back then. I'm not sure we've ever had that happen since.

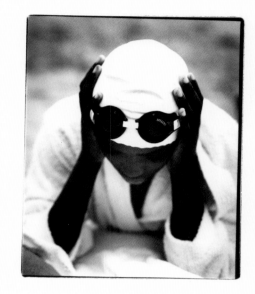

Andrew: I recall we tried to play with the notion of black and white, switching the models' make up and wardrobe around to try and use the negatives as positives. We were unwittingly playing with identity and code switching long before we knew what it meant.

Jo: Swimwear, like the outfits we were showing, was only developed properly after the success of women's suffrage in 1918 and 1928. As such, it can be taken as a powerful symbol of female identity, as Andrew points out, and the ethnic contrasts between Lorraine and Elaine the models were fluid and easy rather than differentiated. This became apparent as we studied the polaroids Andrew and Stuart took before each shot, where I could tangibly see our collaboration emerging on film.

Stuart: The great democratization of photography that has come about with the data revolution is a double-edged sword. On one hand it means that everybody takes pictures these days. On the other hand it also means that 99.9% of the pictures taken are fleeting and transient. The fabulous thing about analogue photography was that there was still an element of utter magic about it - and none more so than the use of polaroid. We used polaroid as a way of pre-visualisation for what we were attempting, as most photographers did, but we also used polaroid as an end product too. Much of the work we still exhibit was shot on original Polaroid Type 55 film. Polaroid allowed us to share imagery, not just in the moment, or for the lifespan of its social media appearance, but as a real souvenir, or record, of the event.

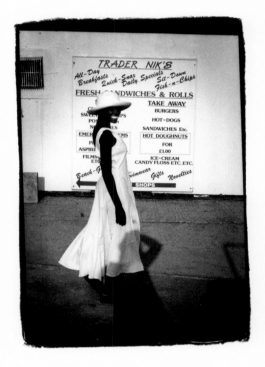

Andrew: In the location van travelling back from the shoot, Jo was very quiet. I asked what was wrong and she said "Wrong?" surprised. "No, right", she said. "I just realized something about how this can work and I'm quiet because I'm bottling it up inside."

Jo: I realised I could be as intuitive and experimental as the Douglas Brothers and that we had created a story which was fresh and unpredictable. It was the first time that I understood what people meant when they talked about letting the magic happen. Now it had happened to me. I wanted to bottle the feeling, and keep it to treasure for as long as I could. That's why I was so quiet on the journey back to London. When I look at the polaroids that Andrew and Stuart took, that feeling washes over me as if it was yesterday. The polaroids showed me that transformation as we were working, which was the power they had - to show you the progress and the direction you needed to take.

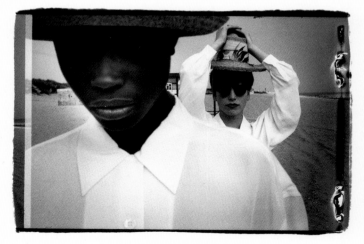

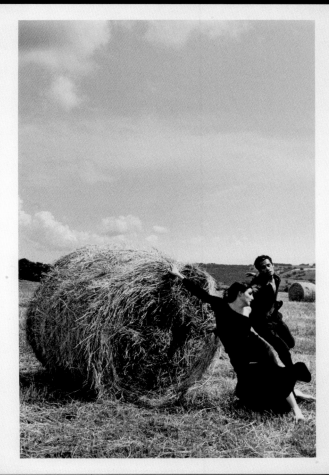

La Capitana

PHOTOGRAPHER: STEPHANIE PFRIENDER STYLANDER
DATE: JUNE 1992
STORY: LA CAPITANA or OUT IN THE FIELDS

Jo: It was my first story for GQ. I'd just arrived and wanted to make my mark. I was keen to steer the magazine away from what it had been featuring for men's fashion, which was fairly static and two dimensional. I wanted to create stories, that had depth and meaning and work with photographers who had the same point of view. I remember seeing a shoot that Stephanie had done, the John Kennedy shoot with Mark Connolly who had been my predecessor. I thought 'oooh, here's someone with a cinematic eye.' Of all the photographers they were then using, I thought Stephanie was the star.

Stephanie: Men's fashion photography looked very formal at the time. There was no story telling, "the pages" just didn't look lived in. The menswear industry was tiny back then, and there hadn't been much creative direction in it, until Jo arrived, who was able to shift the dynamics and tell a story.

Jo: I went to the menswear fashion shows and saw the first Dolce & Gabbana collection and thought 'this is Bertolucci mixed with a bit of L.S. Lowry.' The clothes were high-buttoning, with collarless shirts, granddad vests, and textured, heavy tweeds. They looked as though they belonged to your great grandfather. I started imagining how they would look in a rustic Italian setting, bringing in references to the great Italian film directors Visconti and Bertolucci. Stephanie and I spoke on the phone countless times during the set up for the shoot, but we didn't actually meet until we arrived at the airport.

Stephanie: I was with my assistant Bruno, and Patrick Swan who was doing the hair and make-up, and I saw Jo from the back. She had on a navy blue blazer, I think it was Ralph Lauren. I said that must be Jo.

Jo: We clicked immediately. The location was an ancient, romantic castle in Tuscany which belonged to a friend of mine. It was the perfect backdrop for me to realise my inspirations, in particular Bertolucci's *Novecento* [1900], which I'd recommended Stephanie to watch. To me, its appreciation of beauty without shying away from the dark reality of history and the political struggle between Left and Right, were the contradictions I wanted to capture. That, and the heat, passion and freedom of a Tuscan summer were ideals I wanted to see on the page.

1900 _ "La Capitana"

Photographer: Stephanie Pfriender Date: 6 June - 9 '92

Hair + Make-up: Patrick Swan Issue: October

Models: Luca (Elite)

Yael (Marilyn Paris)

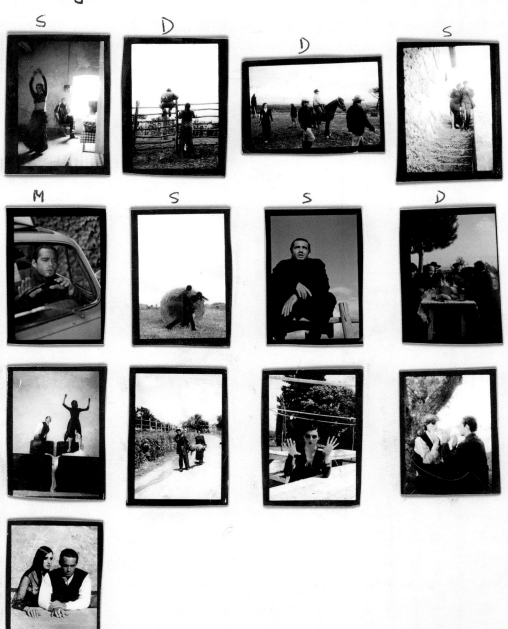

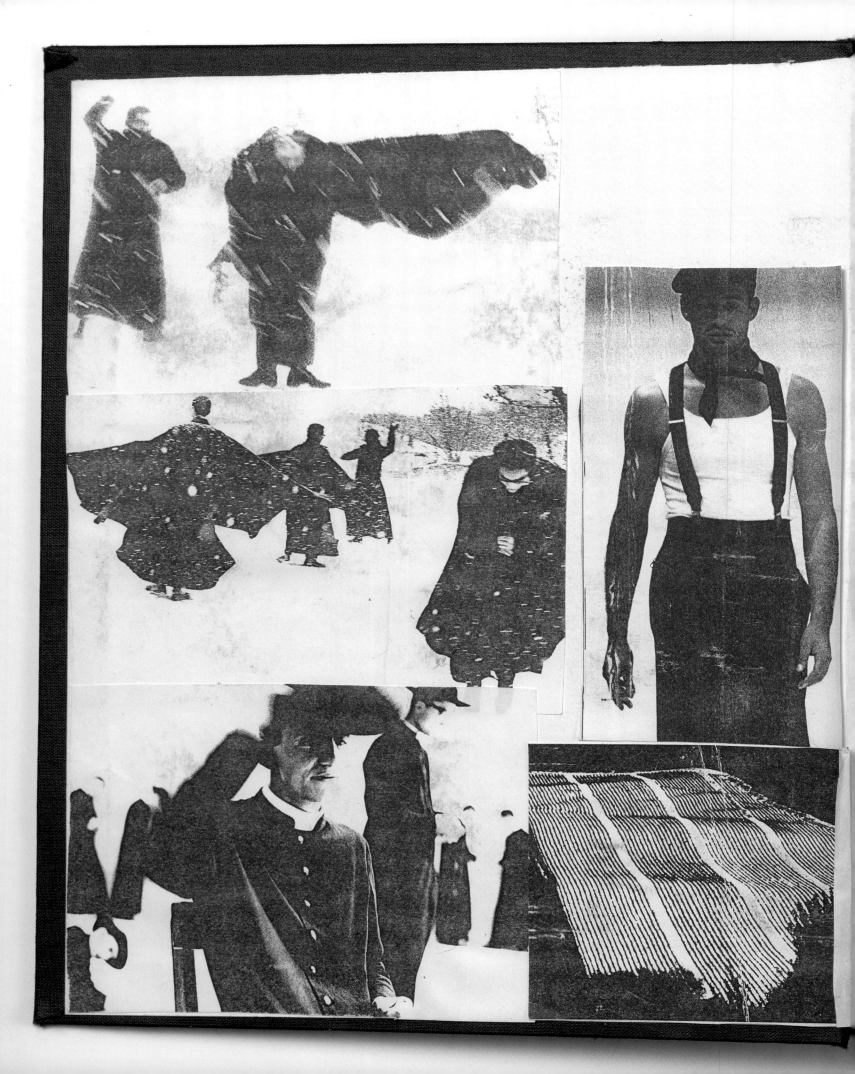

1900 Italy
Vineyards

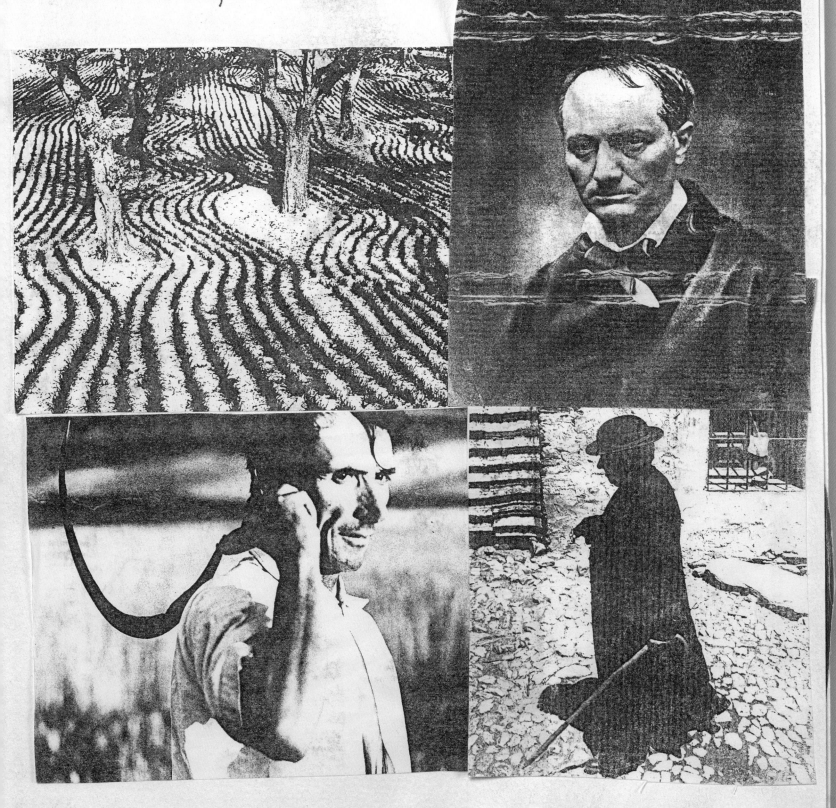

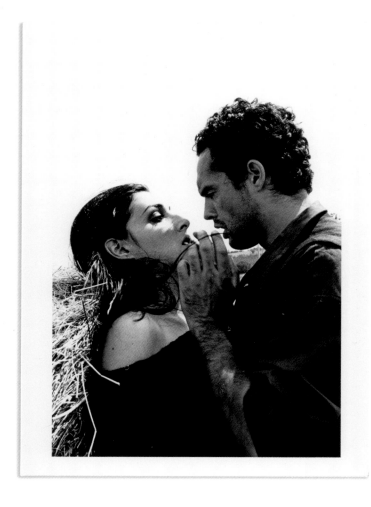 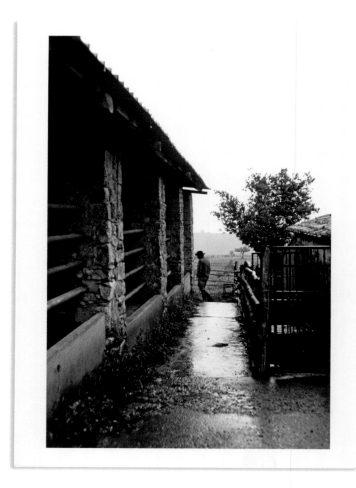

Stephanie: I hadn't seen it before. I was at the beginning of my career, with $10 in my pocket, and Jo said "you have to watch this Bertolucci film." So my assistant Bruno, rented a projector and whatever else we needed back then, and I remember sitting on the floor of my Paris apartment watching this film and being so emotionally caught up in it.

Jo: We wanted to capture the spirit of the land. That, and how the land shaped human outcomes.

Stephanie: Oh YES. My mother was Italian and my grandparents came from the South near Naples. When they came to America in the early 1900s they built a summerhouse in New Jersey for weekends and holidays. On their property was an outdoor bathroom, well water running from a dark green iron faucet; they grew corn, tomatoes, zucchini, eggplant and my grandmother cooked delicious Italian food. There we would sit, all around a large wooden table having lunch in the hot sun. Lots of other immigrant families had built summer cottages there and it became another Europe. It was very much about the love of the land, and so this story that Jo gave me really resonated with me. The clothes were so heavy, they were all tweeds, heavy long sweaters and there you were struggling to carry them. We laid them all out in the barn, on the hay, which was so poetic and beautiful.

Jo: My friend who owned the estate had told me that at this time of year the cattle were rounded up for branding by the cowhands and I thought the pictures of a working farm would add integrity and an extra dimension to the shoot.

As soon as we arrived in Tuscany it started raining so I said to Stephanie 'let's just go with the rain'. Clothes got dragged through the mud, the models' make-up started running and their hair was dripping wet.

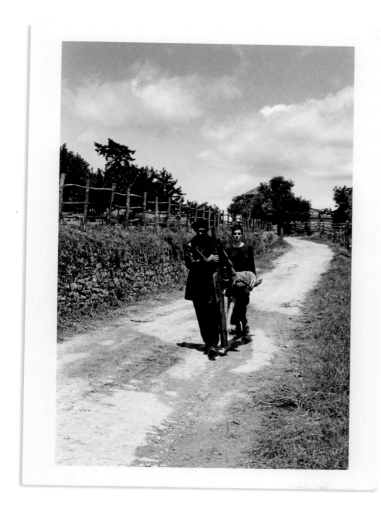

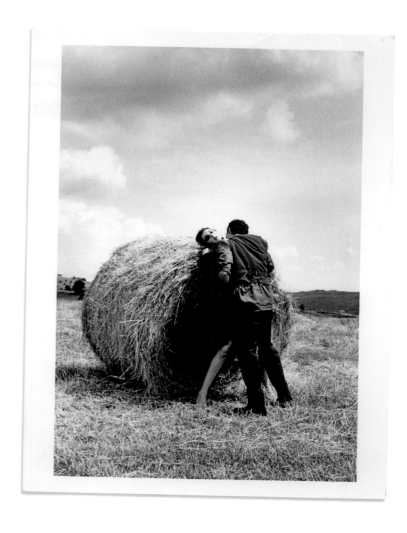

Stephanie: It looked so dramatic, cinematic and real. Yahel and Luca [the models] would drape themselves on the wooden fences, while the cattle roamed around the working cowboys. It was all very cinematic.

Jo: The Estate had its own chapel, providing yet another location possibility. Inside we found a large cross, which we wanted to use as a prop for Luca to carry.

Stephanie: Which you can see him doing in the picture above. What we hadn't realised was that Luca had been raised a Catholic. He became quite nervous about carrying the cross, not because of any thunderbolts from heaven or physical difficulties because of its weight - but in case his mother would spot it in the magazine. "She'll be furious." he explained, "she'll tell me it's sacreligious." We talked him round eventually but he was still very apprehensive. Looking at his face now I can still see a certain amount of stress and I like that

ambivalence in the image. You're not really sure where they are going with that cross or what will happen next.

Jo: When the photographs were handed in to the office they were very nervous. They'd never seen pictures like these. The Managing Director viewed the layouts for a few minutes and then turned to me and said "these are very - er - arty, Jo. Can you explain them to me?" "It's about passion, it's about heat and religion and Italy," I replied. He looked at me as if I'd come from Mars. I struggled on. "It's a mood, it's a new way for men's tailoring – Dolce and Gabbana have made these clothes so sexy because they've put stretch into the waistcoats which mould a man's back in a beautiful way. What Stephanie and I have done is capture the mood and the spirit of Italy which is passion, great food and religion." I could see by now they were wondering if they'd hired the right person. Luckily Michael VerMeulen, who was the great American editor of British GQ at the time, stood up for us.

Michael Roberts

Never Mind the Bollocks

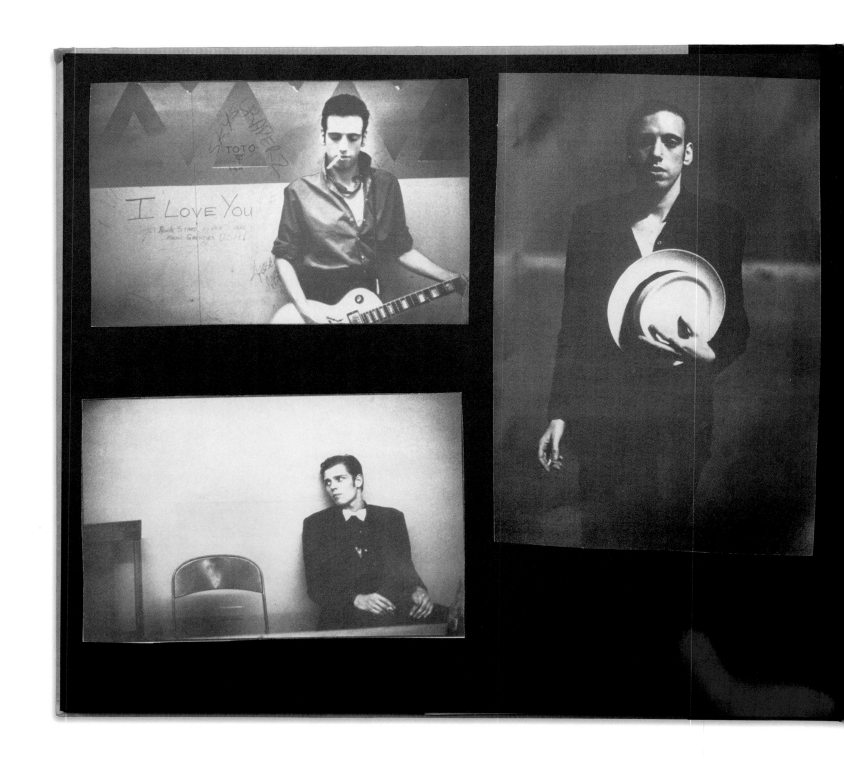

Jo: Nancy Boy was an early Nineties band fronted by Donovan Leitch and Jason Nesmith, which was promoted as alt-glam rock with Britpop influences. They were getting a lot of attention in New York being photographed at the right parties, but outside Manhattan, grunge was everywhere and after two albums Nancy Boy threw in the (make-up) towel. All we knew in the UK at the time was the growing buzz around them, and our Features Director was keen to run a big profile. So I thought I would combine the shoot with that season's menswear collections. Often collections for men need a bit of livening up on photoshoots and the way to do this is to add rock and roll. Your scope immediately broadens out and the music element attracts a wider audience. It also gave me the opportunity to showcase some smaller, up-and-coming designers who didn't

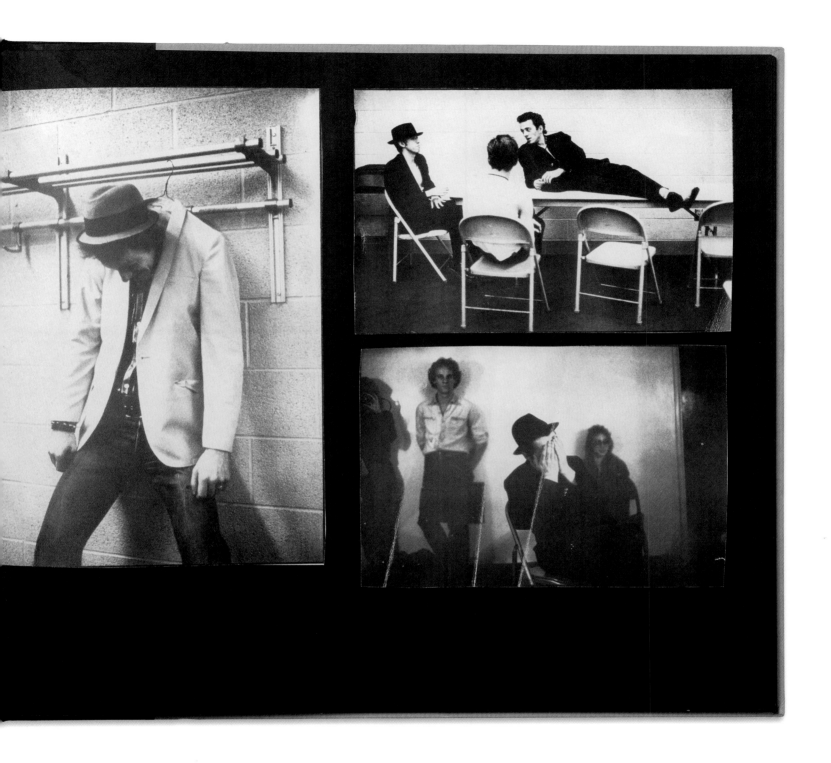

have the budgets to advertise – Raf Simons, Dries van Noten, Number Nine and anything I found at Dover Street Market - were all labels and a store that were relatively unknown then.

I commissioned Michael Roberts to photograph; he has worked in and around various Conde Nast publications over the years, for Tatler, Vogue and Vanity Fair and we used to bump into each other all the time. He always said "let's do a story together" and I thought this one would be the perfect opportunity. Michael is the ultimate voyeur. By excelling in so many mediums he has positioned himself as something of an outsider in that you can't pin him down to any one profession. Like Andy Warhol, he assembles a cast, creates an electric atmosphere and then steps back to record it.

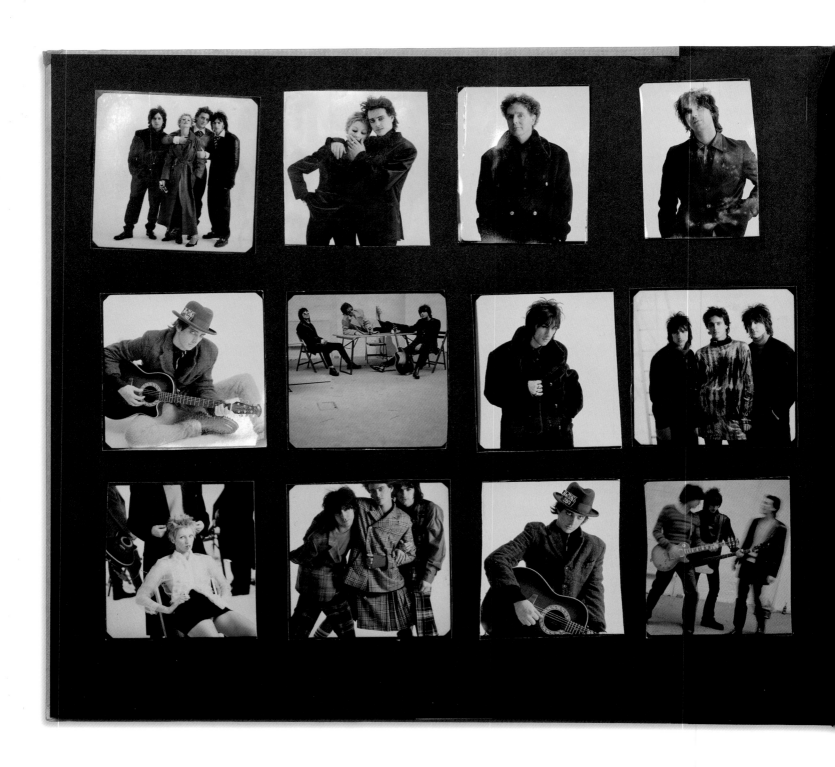

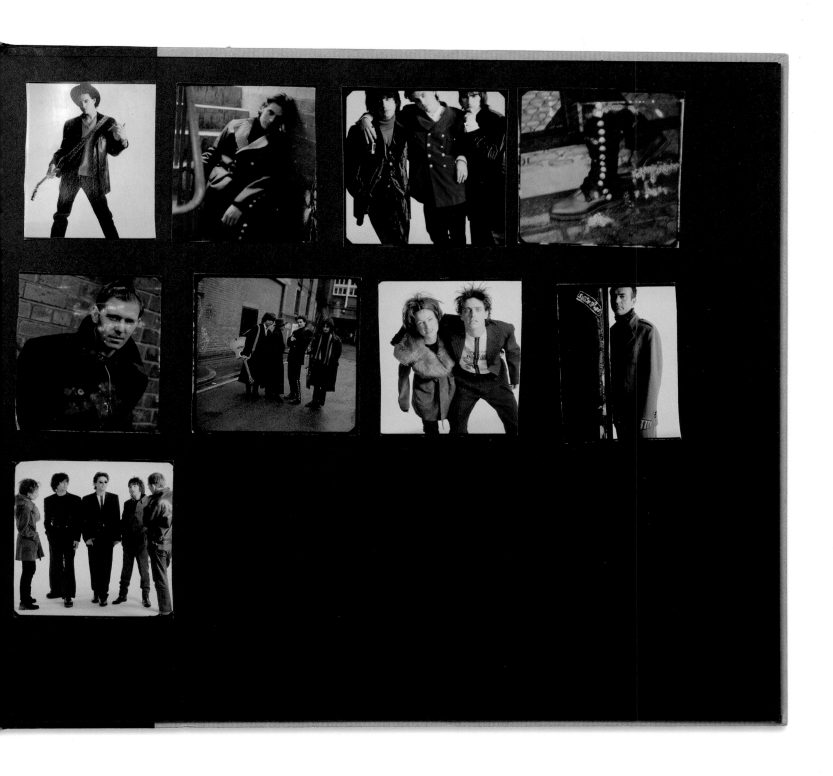

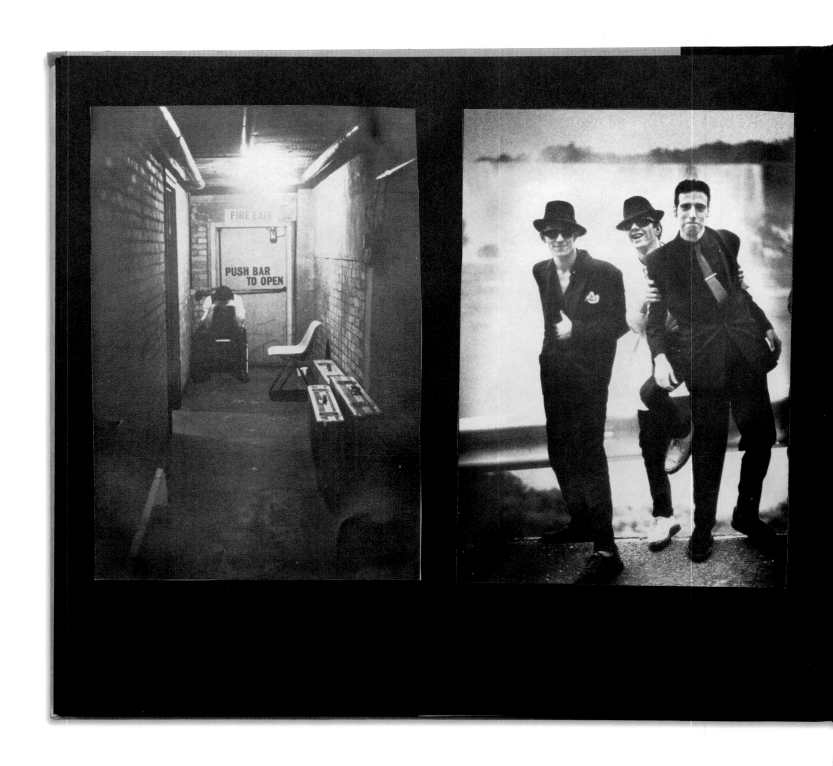

Michael started as an Art Director but branched out into everything that interested him, as an illustrator, stylist, writer, fashion director and photographer, collaborating notably with Grace Coddington. Michael has always had his ear to the ground, picking up even the faintest drumbeat of a trend, and so he was perfect to orchestrate the charismatic group of people that began to assemble in the Old St studios we'd hired.

I was inspired by the book *The Clash: Before and After* by Pennie Smith. Published in 1991, I was very struck by the off-duty pictures, when the band was just hanging out backstage. I photocopied the ones I particularly liked and stuck them into my scrapbook for the shoot moodboard (we were pre-Pinterest and this is how everyone worked). We asked Donovan to invite as many of his friends around to the studio so we could mix them in to the pictures, and I

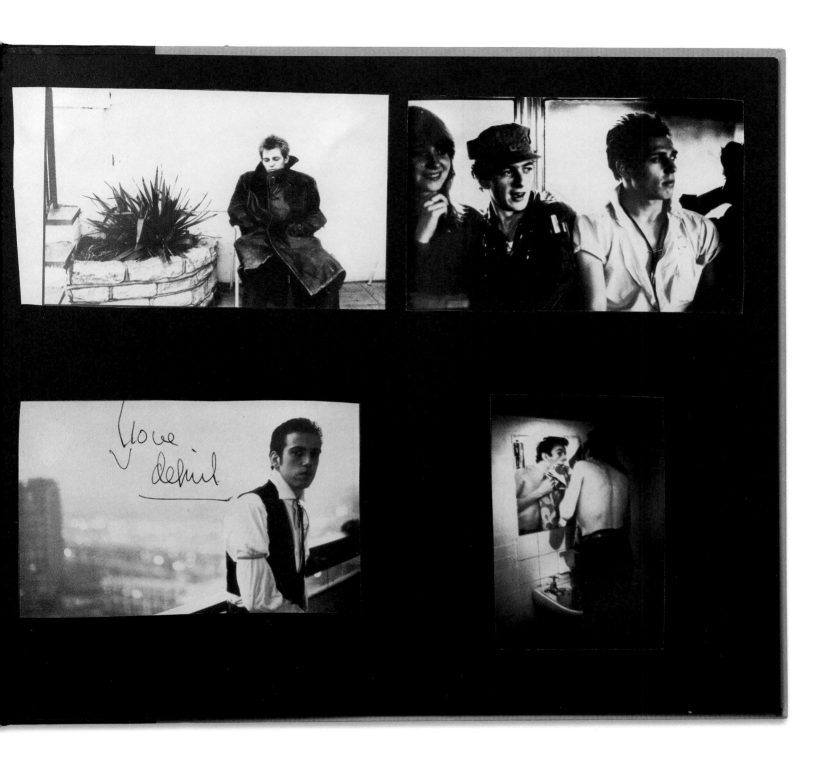

think this worked well because, with the help of the Bowie soundtracks thundering out all day, they were all, in their different fields, professionals and used to having their pictures taken. Malcolm Maclaren showed up as did Joe Strummer, Paul Simonon, Matt Dillon and Hugh Cornwell from The Stranglers. The actress Zoe Cassavetes appeared, fresh off the set of her first feature film, *Ted & Venus*. Supermodel Kirsty Hume arrived and both brought a fantastically edgy glamour with

them. I crammed in as many trends as possible – plaid, tartan, velvet and leather – with everyone goofing around as if they were backstage and/or shooting an album cover. I like what I see when I look at them today, it's still interesting and vibrant. You can feel the optimism of youth and enterprise, most of them were at the beginning of their careers and all of them are household names today. Michael's skill in capturing it all on film is what timelessly binds this piece together.

Guzman

Suburbanites

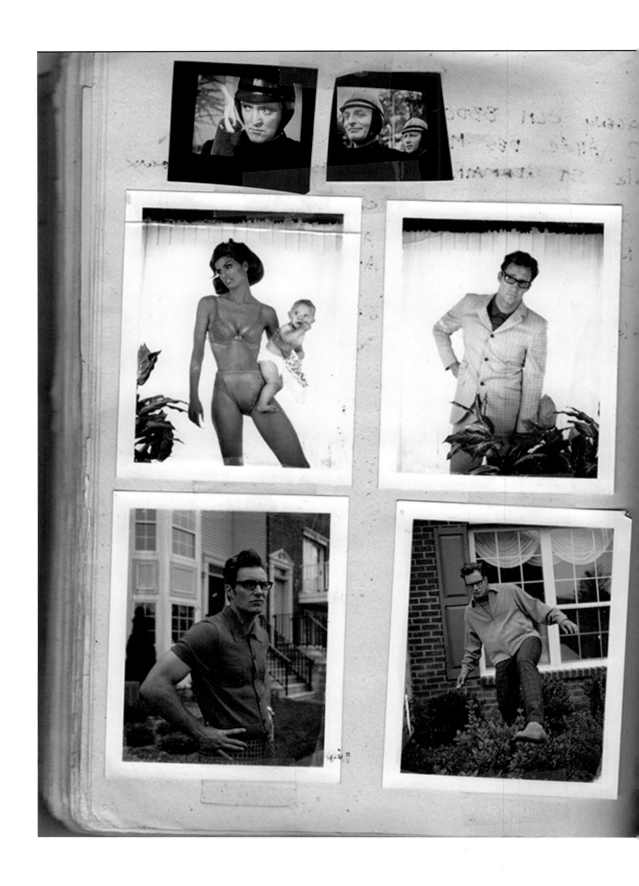

GQ SUBURBIA

LOCATION
SOCIETY HILL
ATTN: DONNA BOYLE
201 332· 5944

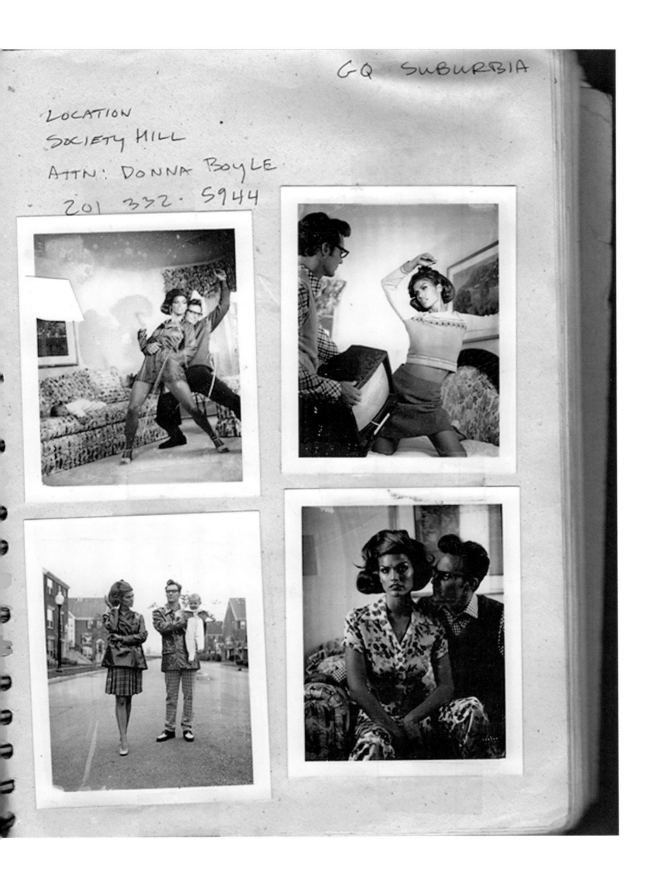

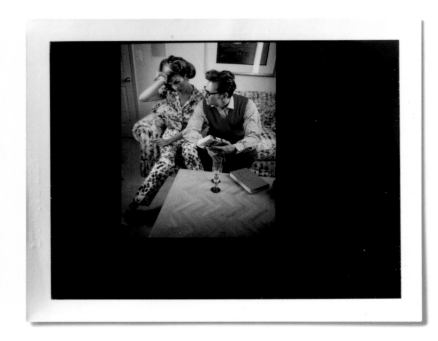

503

PHOTOGRAPHER: GUZMAN (CONNIE HANSEN & RUSSELL PEACOCK)
DATE: MARCH 1996
STORY: SUBURBIA

Jo: I always go round to Connie and Russell's for dinner at their apartment in New York when we've finished a shoot. They live in the most extraordinary space, created by the architects Lot-Ek from upcycled truck containers, at the top of a building near the Empire State. It feels very out-of-this-world, and the Suburbanites story came about one evening when we started wondering, "what would happen if an alien family landed in a housing estate in New Jersey?"

Connie: We found a showhome on a new estate in Society Hill, New Jersey. It was perfect.

Jo: Once we've decided on the story and the location, the clothes, for me, come next. They don't always come first. When I've got my head around the characters in a story, I always think what would I be wearing? Would I know, if I was from Mars, what I ought to wear? So I decided to use clothes with clashing colours and prints, but with a very neat, almost Fifties cut. I found what I needed from that season's collections.

Connie: Our models were fantastic: we booked Shana Zadrick who was a supermodel then, and Danny TMan who we'd used in our work for Vuitton. He was a favourite of ours because he looked really normal, but wasn't ... we gave them mad hair and make-up, and borrowed my neighbour's baby to complete the illusion that they were a suburban family.

Jo: I really enjoy looking at their bewilderment about how to behave like a conventional family. You can see the questions arise – what is a garden? What is a kitchen for? Should we dance now? Maybe... so just put the baby down for a bit and dance.

Connie: I look at these pictures now and you could wear any of these clothes today, because we weren't following any trends. So the story hasn't aged and still makes me smile when I look at it.

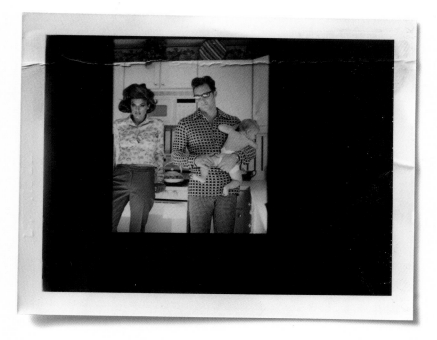

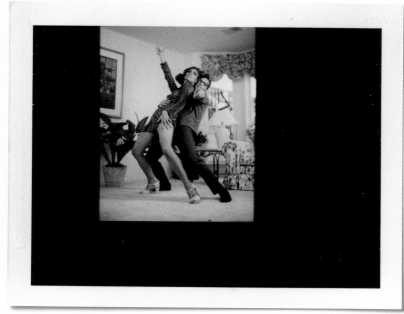

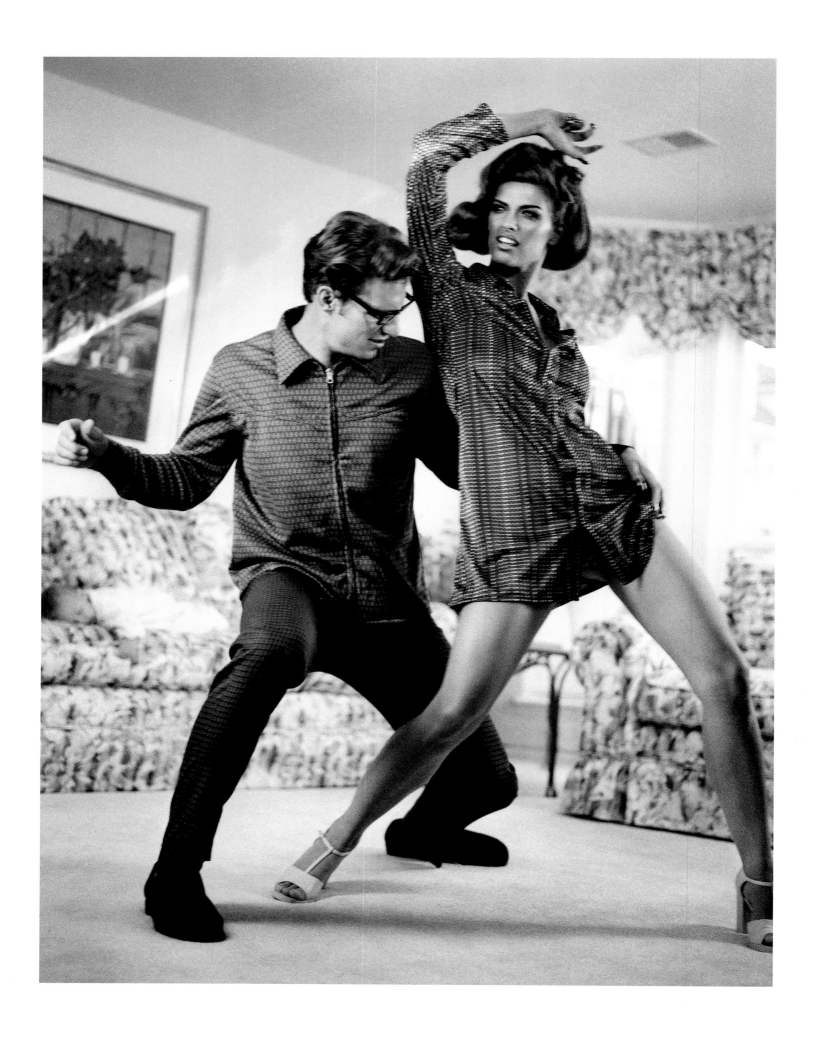

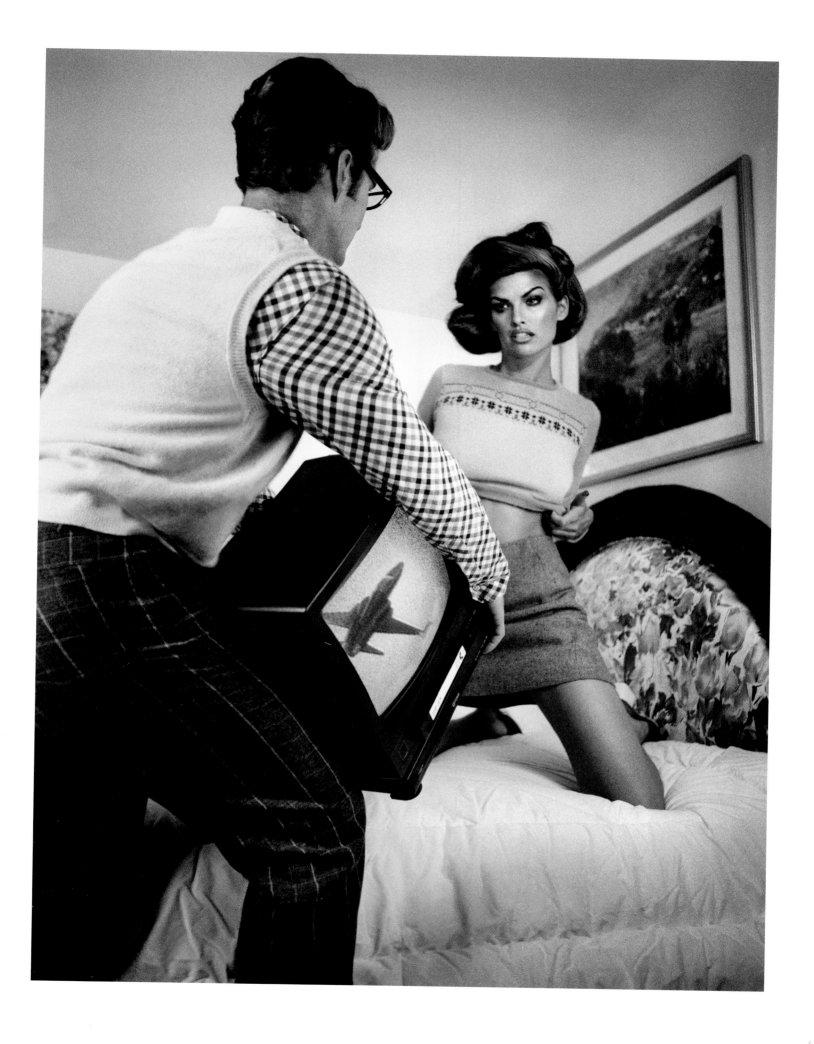

CHAPTER 2
INTO THE MILLENNIUM

(white sweater)
cridist (linen-running pants)

Lots of linen (H)

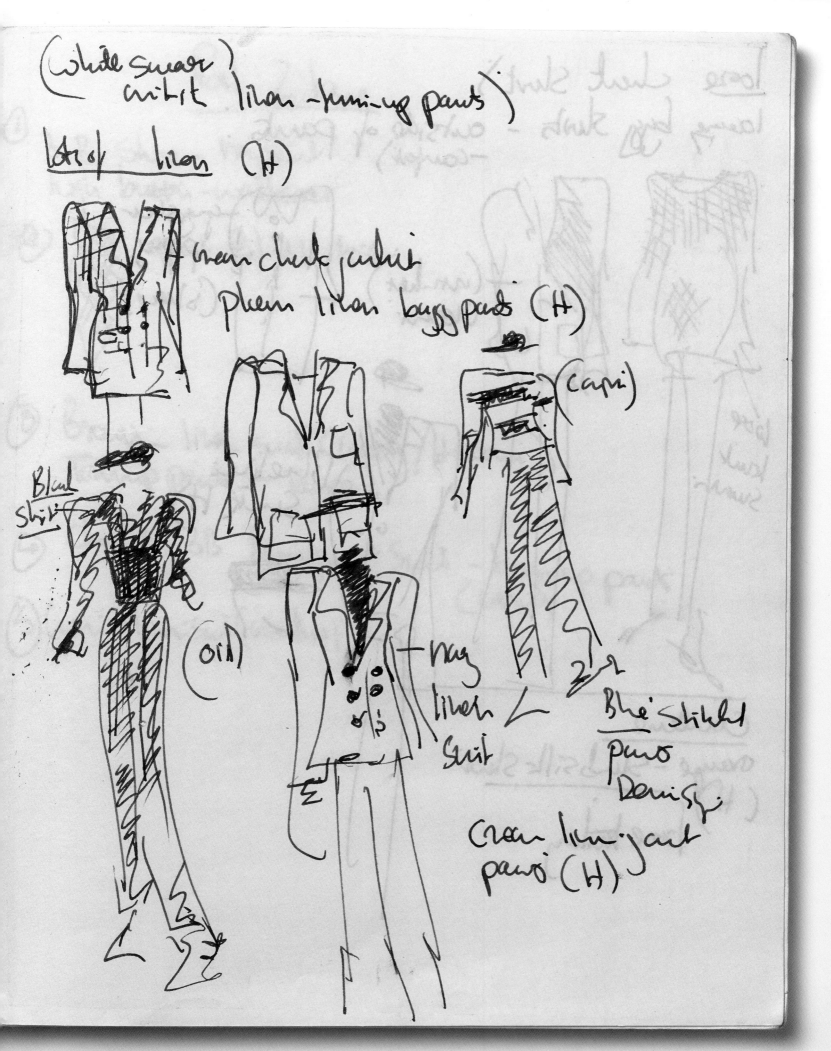

cream check culotte
plain linen bags pants (H)

(capri)

Black
Shirt

(oil)

navy
linen
Suit

Blue stitched
pants
Denim

Cream knit-jacket
pants (H)

Julian Broad

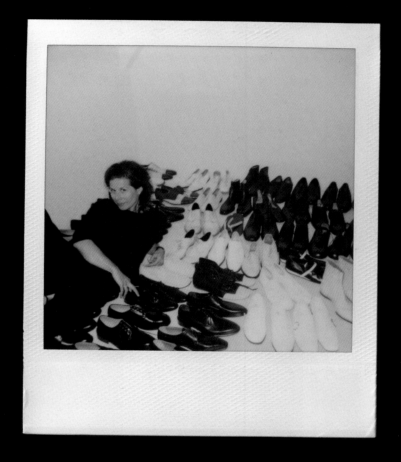

Fashion coming Home

PHOTOGRAPHER: JULIAN BROAD
DATE: JUNE 1998
STORY: FASHION'S COMING HOME

Jo: I was always on the lookout for photographers who were comfortable and good at taking pictures of men, which doesn't always come easily, funnily enough, given that most photographers are men. At GQ I wanted the readers to relate to what they were seeing in the pictures and this meant finding photographers who worked as much outside the fashion industry as inside it. Landscapes, interiors and ordinary people were subjects I needed them to be familiar with. One of the reasons I wanted to work with Julian is because he is very easy with all of the above, and has a particular skill with photographing men. He has a very elegant eye, and lights beautifully but is also fanatical about rock and roll, musicians and motorbikes. His style seems effortless but that's because he's trained with the best – Parkinson, Snowdon and Bob Gothard.

Julian: Jo and I met on a shoot in Metro Studios on Peartree Street – but forgive me, I don't recall who we were shooting – it could have been Leonard Cohen or it could have been Chrissie Hynde. I do remember Jo shouting at me for being on my mobile phone.... She didn't like mobile phones. She demanded 100% concentration, which was fair enough.

It would be easy to think that Jo is 'not of this time' and that she comes from a distant past – the world of Beaton and tea at Claridges (which she loves in fact) - but you'd be mistaken. You'd have fallen into a trap. She's very tough, very kind, very demanding and she would do ANYTHING for a picture. Yes, the story changes on the shoot – but always there was a seed to get the whole thing moving – to give it form.

Jo: As it was the September issue we had to show the autumn/winter collections, which, that year, were Crombie coats, Harrington jackets and denims. The inspirations we had were the British films *Trainspotting, Secrets & Lies* and *Kes*. For this we needed a bleak urban location with grey skies and institutionalized architecture showing a darker side of English life.

Julian: We found Barnsley in South Yorkshire was the perfect spot. A former glassmaking and mining town, in the Nineties unemployment there was well above the national average as by 1994 the last coal mine had closed down.

Jo: So if you were young growing up in Barnsley what would you be doing? There wasn't much work available and nothing much going on. So I referenced rock and roll, young guys coming together, forming a band and hanging out. At the same time you get a feeling of them being at a loss. I think some of these images would be great on an album cover.

Julian: I'm a portrait photographer primarily, but I've always enjoyed working on lots of different projects and this fashion shoot in Barnsley is a good example of how my portrait work was starting to bleed into fashion pictures. Models looked like 'real kids'. Realism was the starting point and inspirations could come from a record, a film, a bit of a book or a snippet of a tale. Larry Clark and Ken Loach's films with John Bulmer's pictures of the North of England were our references at that time. So, we all piled into a mini bus and went up North with a stack of clothes.

Jo: In those days when we went to exotic locations we were really lucky to get all of it sponsored, from the airlines to the hotels. But a palm tree, a beach or a pool could be anywhere. I liked to show more than just the immediate background, and create a sense of place. I think that's what you're also seeing here, somewhere that's just as interesting as the clothes. Julian can frame a shot just with his eye, before taking the picture. I used to stand by him and get that feeling in the pit of your stomach that he'd captured it – with his eyes. So the story didn't change from its conception to realisation and we achieved what we'd set out to do. The polaroids are very close to the finished images, in fact I think in this instance Julian took the back of the polaroid and developed it so that some of the magazine prints are actually the polaroids he took.

Julian: Digital versus polaroid is an impossible comparison. Photography is, in the big scheme of things, such a young medium and it would be dangerous to attach too much importance to either in fact – they are both transitional periods in photography – both have their merits and both their flaws. I think the polaroid is becoming more charming as the years pass. That particular tone – the softness of them and that fact you can pick them up and stick them in your diary or look at them on the bus on the way home.

What was great about them is they didn't actually give you (the photographer or the stylist) a 100% accurate record of that picture – It would look 'something like that', and was a sketch or a vague indication of the final picture. We were always keen to get back after the shoot, to develop the film and get in the darkroom and get the 'real pictures' out. "Don't worry! It won't be as blue or green or washed out or dark or light as this" that was our cry - as we tried to convince an uneducated client.

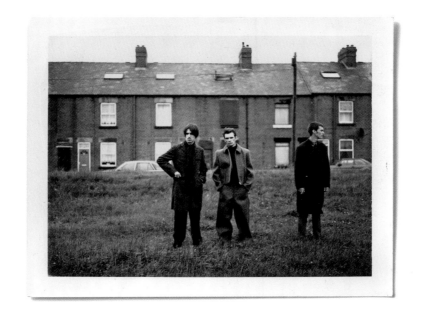

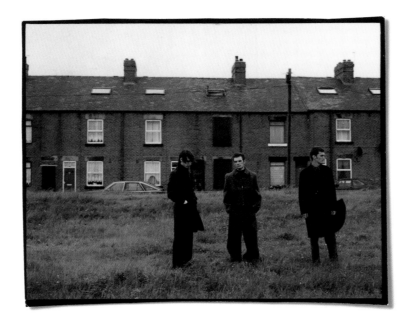

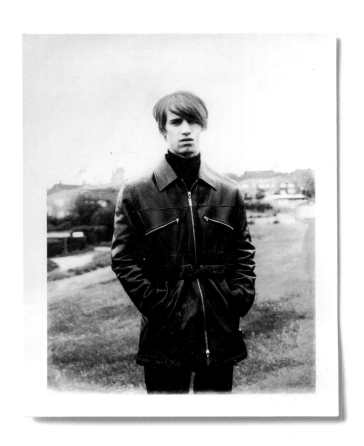

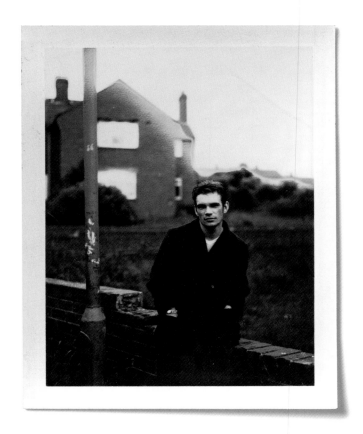

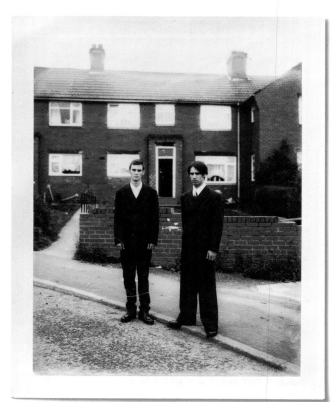

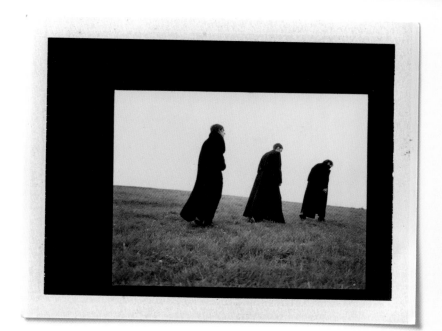

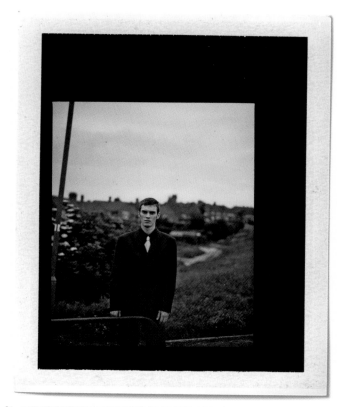

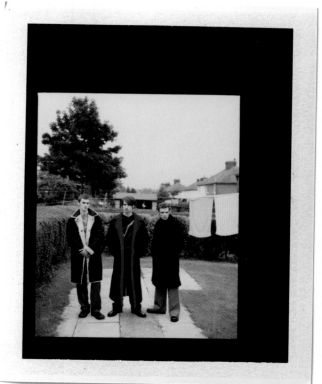

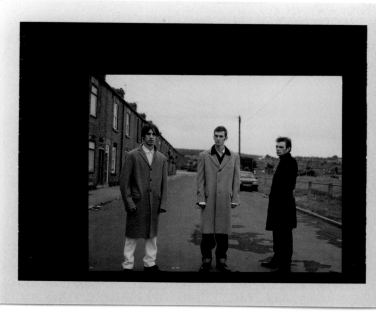

PHOTOGRAPHER: WILLIAM CLAXTON
DATE: SEPTEMBER 1999
STORY: HOUSE OF BLUES

Jo: The more conservative nature of men's clothing (compared to women's fashion) meant that I was always looking for fresh ways to present it. Sometimes it felt as if the very tradition of men's tailoring encouraged a blank canvas – and onto this I could paint the colourful storylines that brought the clothes to life and gave them meaning.

There was one photographer whose work I loved and could only find on the postcards that I bought from a little shop next to the Deux Magots in Paris. This was William Claxton, who since his Sixties heyday had fallen slightly out of circulation. I loved the geometric precision of Claxton's perspective, framing subjects in poses that mirrored their environments. It so happened that the 1997 Spring collections had a very Fifties feel about them, and reminded me of Claxton's jazz musicians on the pile of postcards I now treasured in a drawer of my desk.

I managed to track William down to his home in LA, and our first shoot together, inspired by his work as the documenter of all the jazz heroes - Duke Ellington, Charlie Parker, Count Basie, Thelonius Monk and of course Chet Baker - featured many of the great musicians who were still playing. Joe Henderson, McCoy Turner, Charlie Haden and Ron Carter all shared a mutual admiration and respect for the photographer that had put the genre so firmly on the map.

So when the opportunity arose for a second session with William, I flew down to LA to have dinner with him and his iconic wife, Peggy Moffitt. William had similarly immortalized Peggy as the Rudi Gernreich swimsuit muse, and I was just as in awe of her. During dinner I was asking William about his career and what were the standout moments for him. "Chet Baker, Peggy and of course my work with Steve McQueen" he replied. "What work with Steve McQueen?" I asked. In reply, William got up and went and found a dusty old box of prints. "Here" he said, and inside

were these incredible pictures, where it was immediately apparent that not only was Steve a superb model in (his own) clothes but that William had managed to capture the essence of the man. Seen behind the wheel of his Jaguar, peering over the rim of his sunglasses elevated McQueen beyond the Hollywood system because his own personal style was far greater. His and William's shared passion for sports cars and motorbikes created a bond that was clear to me from the images I was looking at.

I knew I had to do something about these pictures that no one had ever seen. "If you get a book deal" I said, "I'll organise an exhibition to go with it." When Taschen bought the publication rights, I went straight to see Michael Hoppen about his gallery putting on a show, and then arranged for Tag Heuer to sponsor it, after I'd noticed Steve McQueen was wearing their watches in the photographs. Which was nice of me...

In the meantime we had a shoot to get on with, and because that season's collections had contained so much blue I was inspired for the pictures to resemble the classic Blue Note jazz album covers. Continuing along the blue theme, the location chosen was the newly opened House of Blues on Sunset Strip, which was the place in those days and was packed every night. Except for the night when I ate crab cakes. That did not end well for me, with an early exit to my hotel bathroom as a reward.

The shoot went brilliantly and I relied on William to call in the players he knew and it was the most relaxed session I'd ever had. There was an extraordinary camaraderie between them, born out of mutual respect for each others' genius. I look at these polaroids now and to me, each one could be a Blue Note jazz album cover. William died in 2008 and while I miss him very much, the work we did together endures, and brings him to mind each time I look at it.

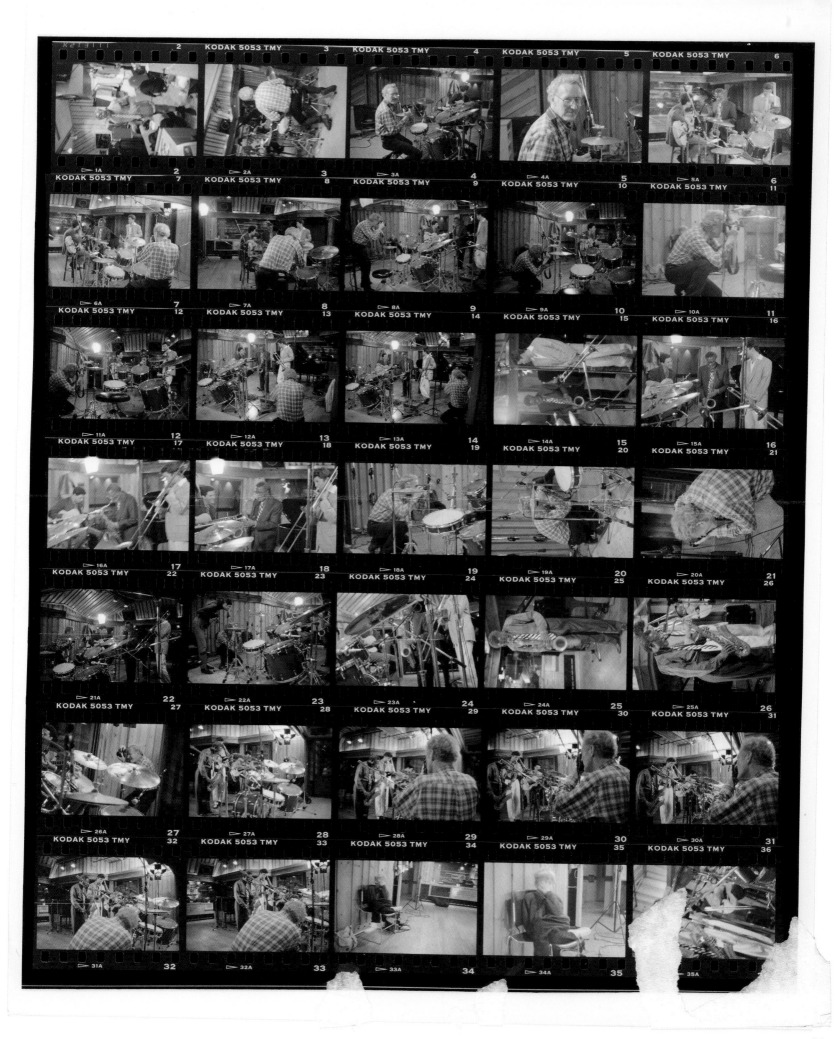

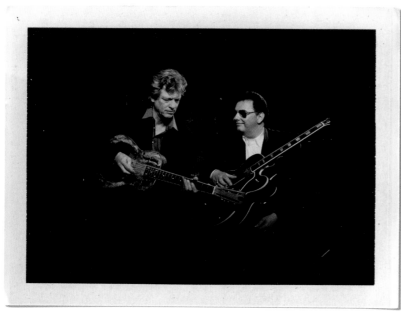
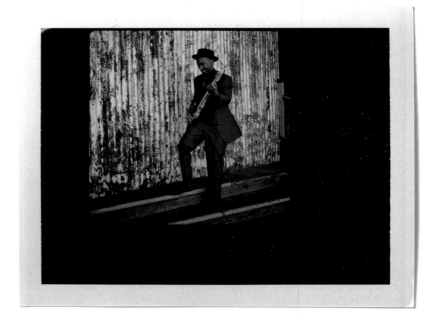
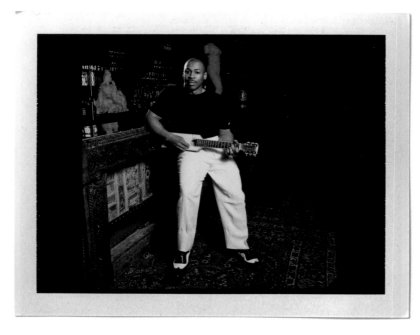
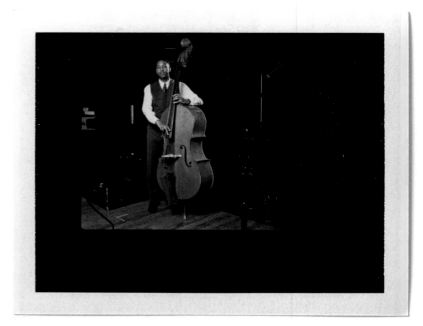

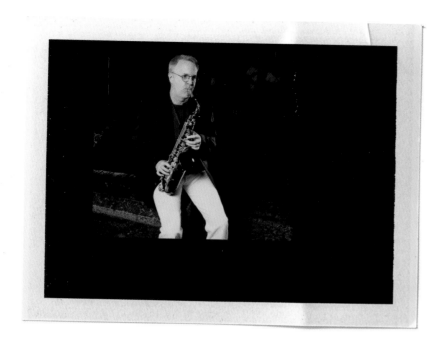

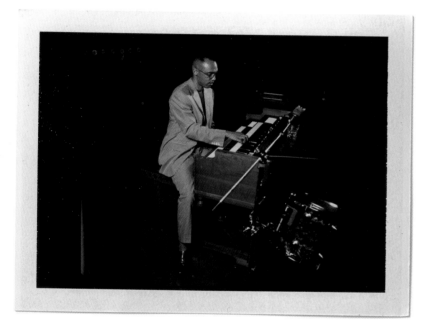

William Claxton

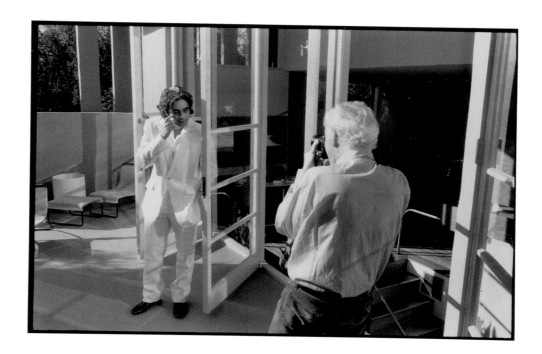

Benicio Del Toro

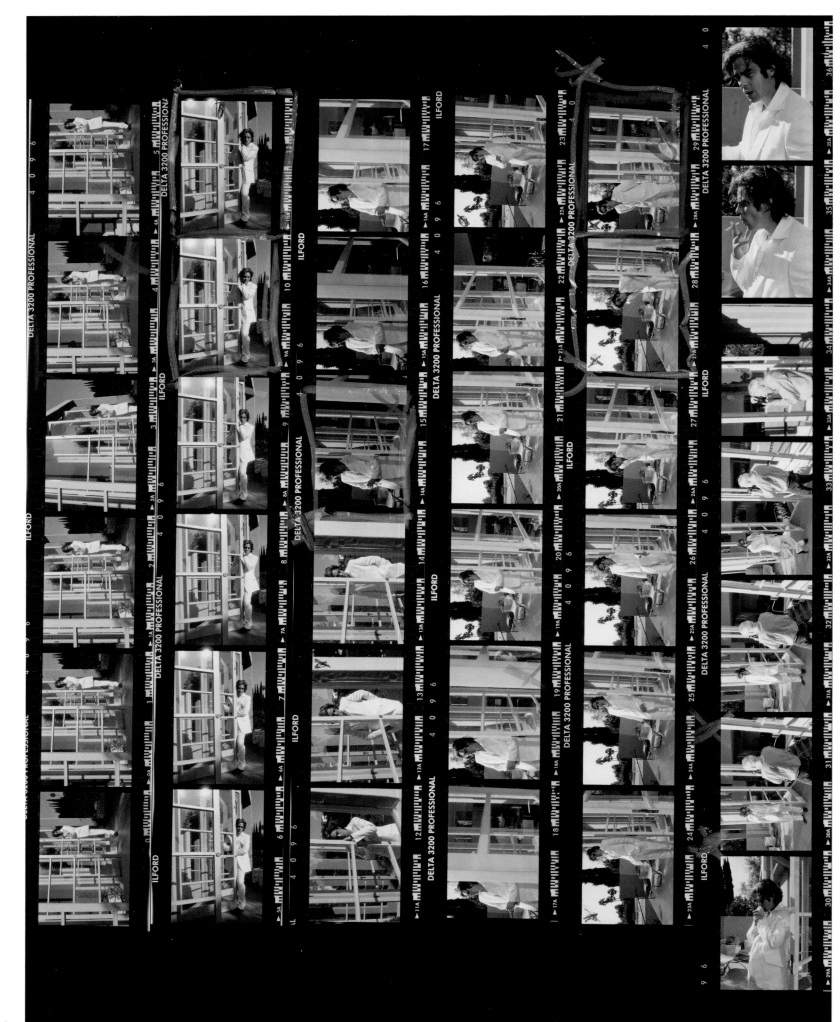

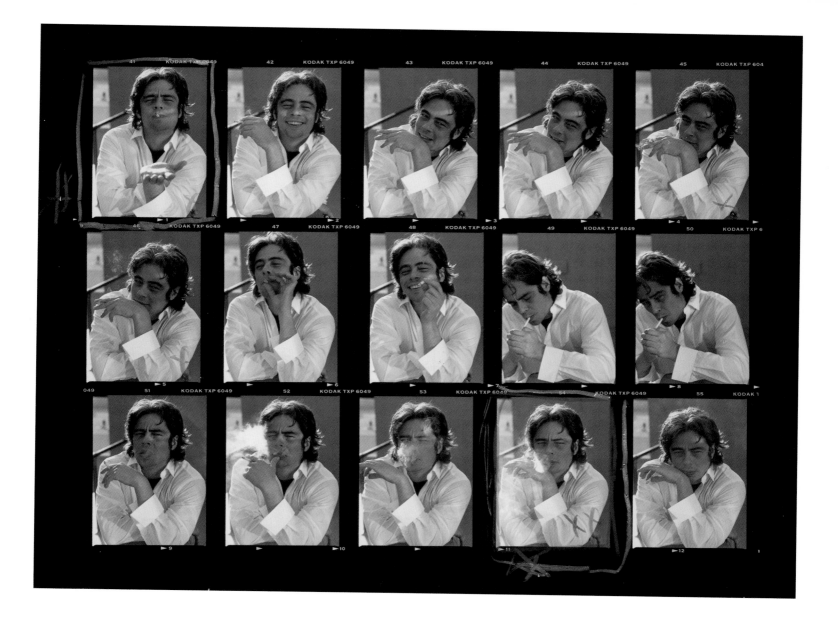

PHOTOGRAPHER: WILLIAM CLAXTON
DATE: JULY 2002
STORY: BENICIO DEL TORO

Jo: It was the GQ Man of the Year awards and Benicio, having won the Oscar for *Traffic*, was our International Man of the Year. I was sitting next to him at dinner, and we started chatting about photography. We discovered we were both fanatic about it, and as I'd always wanted to photograph him, suggested that I set up a shoot with my good friend William Claxton. Benicio nearly fell off his chair. "Not *the* William Claxton?" he asked, "who shot those extraordinary pictures of Steve McQueen? I'm crazy about those pictures." "The very one," I replied "and what about getting him to shoot you on the same 35mm film that he used for Steve McQueen?" Benicio looked at me. "Done" he said.

The project came together very quickly – in my view, you have to strike while the iron is red hot. The awards are always held in September, so it must have been November when I flew to LA, having scheduled the piece to appear in the following July issue. William was equally excited although a little concerned when I mentioned shooting on 35mm. Film processing for 35mm had become too refined since the 1960s, so the challenge was to try and recreate the same grainy, raw feel.

I'd already had an idea for what Benicio should wear which were white, crumpled linen suits. I wanted him to look like an unmade bed and as Benicio is not an early morning gentleman, when he turned up at midday I was pleased to see that was exactly what we were going to get. Nor was there an entourage – Benicio arrived completely on his own. That's what made the shoot flow so well, because photographer and subject were able to create an intimacy that I feel comes through very strongly in the images. In fact they got on like a house on fire. We shot through the afternoon and into early evening, catching the very last rays of Californian sun and it was magical.

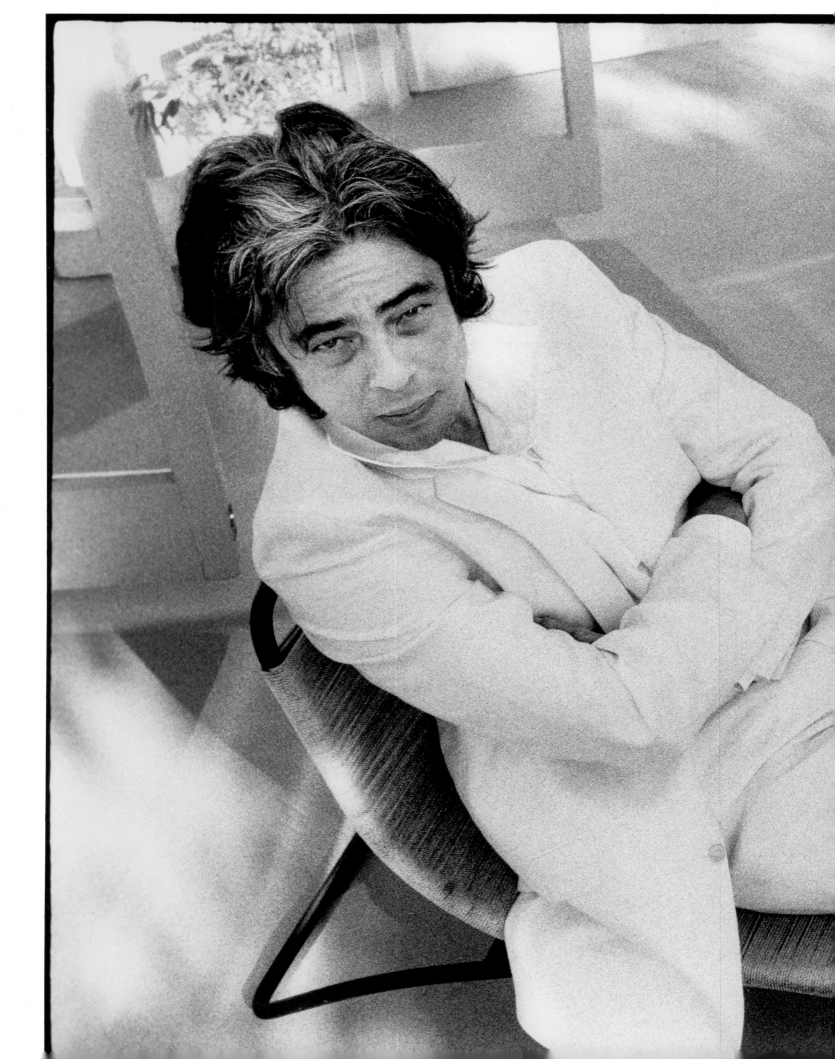

Peter Lindbergh

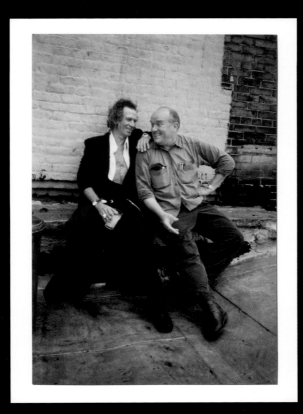

Keith Richards

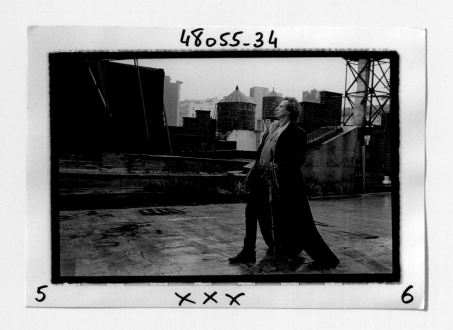

48055-34

5 X X X 6

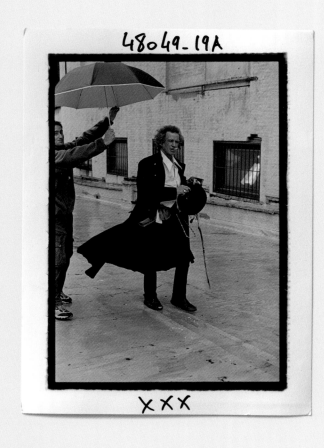

48049-19A

X X X

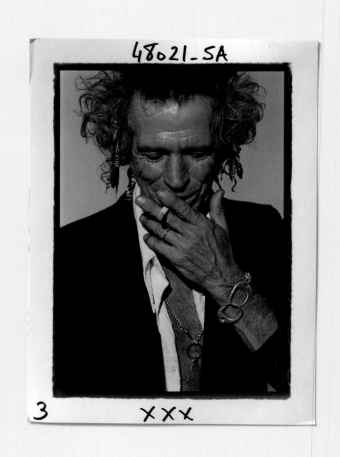

48021-5A

3 X X X

66

PHOTOGRAPHER: PETER LINDBERGH
DATE: OCTOBER 1999
STORY: KEITH RICHARDS

Jo: I was and am a huge fan of Peter Lindbergh and my dream was to work with him. So I had to find a way of bringing this about. I was working at *The Independent* with the editor Liz Jobey and suggested a piece on Irene Salvagni, the former editor of French *Vogue*. Irene was another heroine of mine, someone who had nurtured a raft of young photographers who had all become world famous including Steven Meisel, Bruce Weber, Paolo Roversi, Max Vadukul and Peter Lindbergh. I said to Liz "Irene is the best kept secret in the industry and ought to be better recognised as a great editor. Why don't I go down to her country house in Arles and have her talking about Peter Lindbergh while he takes pictures of her?" Liz thought that would be great and off I went. That's when I met Peter and luckily for me, he'd admired a piece I'd just done which was a shoot with Deborah Turbeville. So when GQ put Keith Richards up for Man of the Year award in 1999, I was able to pick up the phone to ask Peter to work on the project with me.

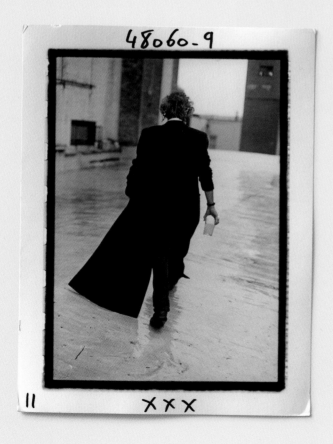

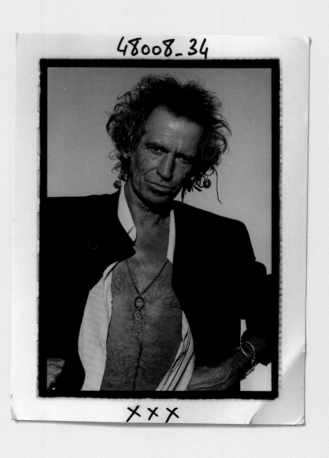

My inspiration was the cartoon character Top Cat, the Manhattan alley cat living amongst the garbage cans. I said to Peter "can we find a flat roof in New York to shoot on? I'll find a company to deliver the garbage bins." Peter roared with laughter and agreed. Then I called up Jane Rose, Keith's longtime personal manager. I didn't tell her about Top Cat or the flat roof, but I explained the shoot would feature a winter story using long coats in which Keith could swagger around the garbage bins with ease. Peter had found a studio that had a flat roof with all those old water tanks on it and it was perfect. All my garbage bins had arrived but it was pouring with rain, and we had to drag these up the stairs one by one, getting soaked. "Jo what are we going to do about this rain?" asked Peter, worried. "It'll be fine" I said. "Keith's British, he can cope with it." Just then Jane Rose arrived, with her little dog who was dyed bright pink. She too was concerned about the rain. "What's your concept here Jo?" she asked. I was just starting to explain when Keith arrived. On time. "Hi babes, how are you?" he said giving us both hugs, "what are we doin' today?" He didn't bat an eyelid about going out into the rain, or climbing up the stepladder to the roof. "Right, let's do it" he said. When it came to the styling, the hairdresser found a little charm that had got tangled up in Keith's hair. She couldn't get it out. "Yeah I woke up with that this morning" he said "I couldn't get it out either." "Let's add more in then" I suggested and that's how we ended up with lots of charms and ribbons in Keith's 'coiffure'. I hope this was the inspiration for Captain Jack Sparrow. I really do. There was a warehouse across the street and the guys working there had spotted Keith on the roof. "Hey Keef! We've got a demo tape here, will you listen to it?" they shouted. "Sure thing" he said, and they threw it up and he grabbed it. It was hilarious, and one of those rare shoots which was magic and effortless. Peter was thrilled, as was Jane when the pictures came out. Now I think they're some of the best – I think John Galliano bought one the other day at auction for thousands.

Dear Jo –

Here are some of the
photos from that incredible
day!
 Look forward to working
with you again.
 Warmest regards,

 Jane

JANE ROSE

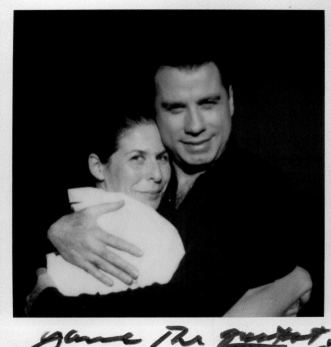

PHOTOGRAPHER: PETER LINDBERGH
DATE: DECEMBER 1999
STORY: JOHN TRAVOLTA

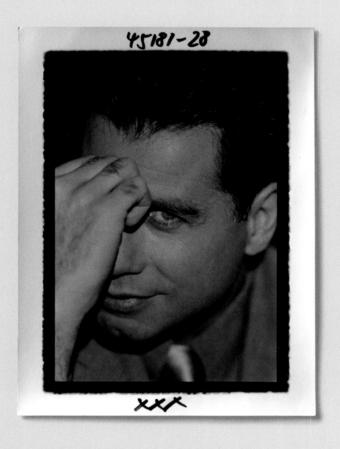

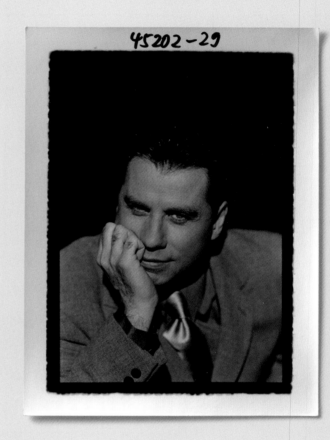

Jo: Donna Karan and John Travolta are great friends, and I think John is always dressed by her. So I was in the DKNY offices in New York having a meeting with Patti Cohen, head of PR, when she asked me if I'd be interested in a cover story on John for British GQ. He had a film coming out, *The General's Daughter*, and was once again massively in demand due to his phenomenal performance in 1994's *Pulp Fiction*. Of course I said "Yes!"

Back in the office we were very aware of the need not to mess this one up. But I was having doubts about the photographer that John's team had proposed. I wanted the pictures to be powerful, strong and iconic and I knew that the best person to capture John's status would be Peter Lindbergh. So I needed to persuade John, who had never sat for him, that this was the right way to go. My art director

said "it's very risky Jo, this is a gamble which might not pay off and I hope you have Plan B up your sleeve."

John had requested a meeting with me, which I decided to use as an opportunity for a fitting. Three weeks ahead of the photoshoot, I selected the clothes from Donna Karan in New York, who shipped them down to LA. John was on set, and I turned up at his trailer with the rail ready. As I started working I allowed myself a surreal moment. "Oh my God, I'm doing up John Travolta's tie" I thought.

I could see John was very happy with the clothes as he did a little dance. "I like those moves," I said "we could use those on the shoot." "Well you know I used to dance a little" he replied. "Yes, I know" I replied, "and I'm a big fan." I got a hug for that, and it gave me the confidence to

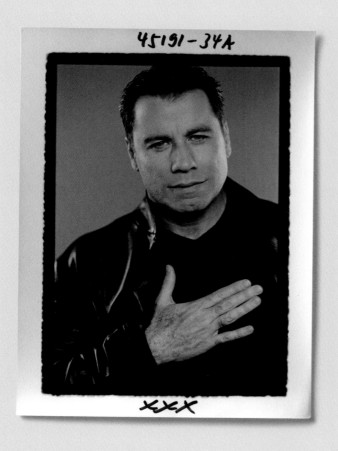

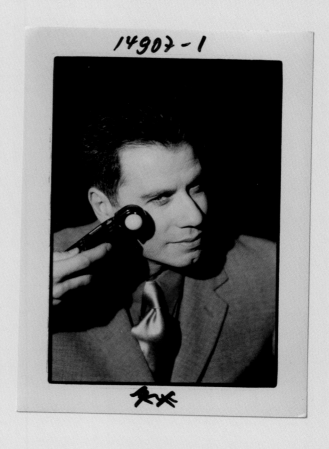

introduce the subject of Peter. John was understandably apprehensive about working with somebody new. "He's the right photographer for you" I pointed out, "You're premier league and so is he. You'll get pictures that will become collector's items." I left the trailer having secured John's OK, which was a wonderful feeling.

Three weeks later Peter and I flew out to the Sunset Marquis, where Peter always stayed and always in the same bungalow. We'd already had several conversations about the shoot, but we still had a final meeting in his villa eating the most delicious sushi and sashimi and going over the final details for the next day. We'd only been given three hours with John and knew that we had to be really organized. Preparation is key. You have to know exactly what you're doing from the clothes, to the location, to the

set-up and lighting.

Peter had five different lighting set-ups prepped in advance. Peter is also very quick at working. I remember one shoot he and I did with the footballer, Ronaldo, who was late to the session. We had three minutes left so I ran outside, grabbed his arm and said 'Drop your trousers now!'. I bundled him into the shoot tracksuit bottoms and virtually threw him into the studio – Peter got the shot in two minutes flat. So when John arrived and everything had been arranged to make things easy and comfortable, he and Peter hit it off immediately as I'd hoped. As we neared the end of the session I knew I could articulate what I'd been dying to ask John all along. "Do you think you could dance on tippy toes like you did in *Pulp Fiction?*" I asked. John cracked a huge smile. "Sure" he said. And he did.

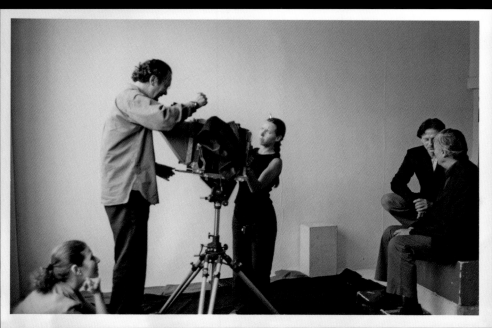

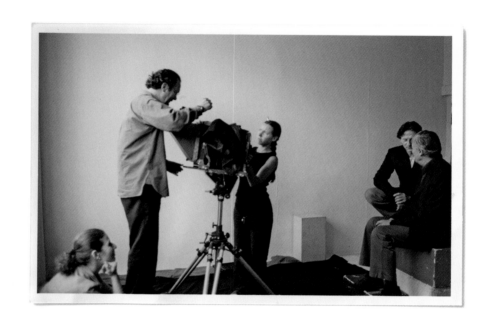

Dana Lixenberg

The Golfers

PHOTOGRAPHER: DANA LIXENBERG
DATE: DECEMBER 2001
STORY: THE GOLFERS

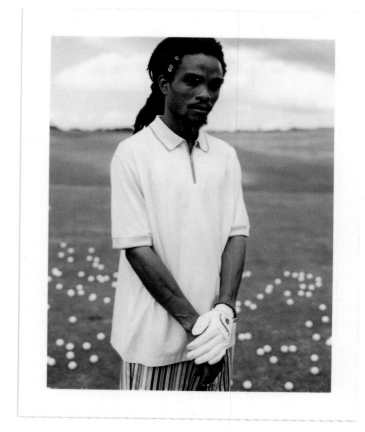

Jo: I was scheduled to do a shoot in Nepal but the photographer we'd booked had gone down with a back problem. He was an expert on India, but never having been there before myself, was filled with anxiety about who his replacement might be. I went round to his agency who suggested Dana Lixenberg. In fact, Dana was due in the office in five minutes time, they said, so would I like to meet her?

Dana: We went to have a cup of coffee and chattered away. We discovered we were both going to LA at the same time, and we met again for breakfast there.

Jo: I decided that, no matter what, Dana was someone I could venture into unknown territory with and everything would turn out just fine.

Dana: We were booked into the iconic wildlife lodge Tiger Tops, in the Chitwan National Park. We were sharing a cabin but when we got into it the walls were crawling with giant spiders. Uggggh. We ended up moving our beds close together away from the walls. The dining room was some distance from the sleeping quarters, and we were terrified to get from one to the other, huddling together in the dark surrounded by the screeching of jungle animals.

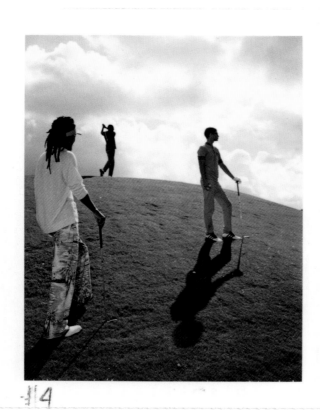

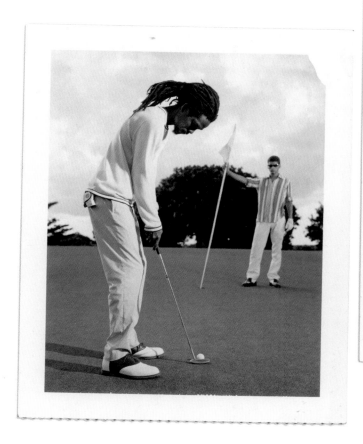

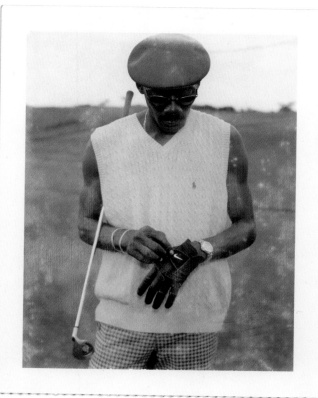

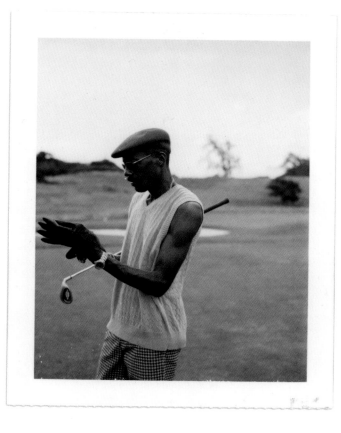

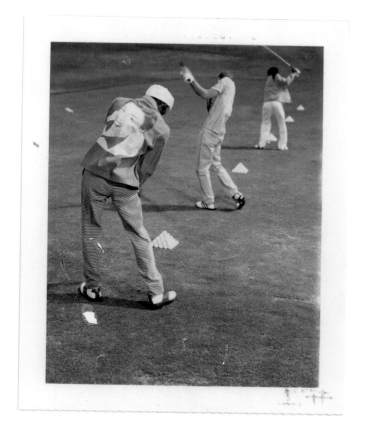

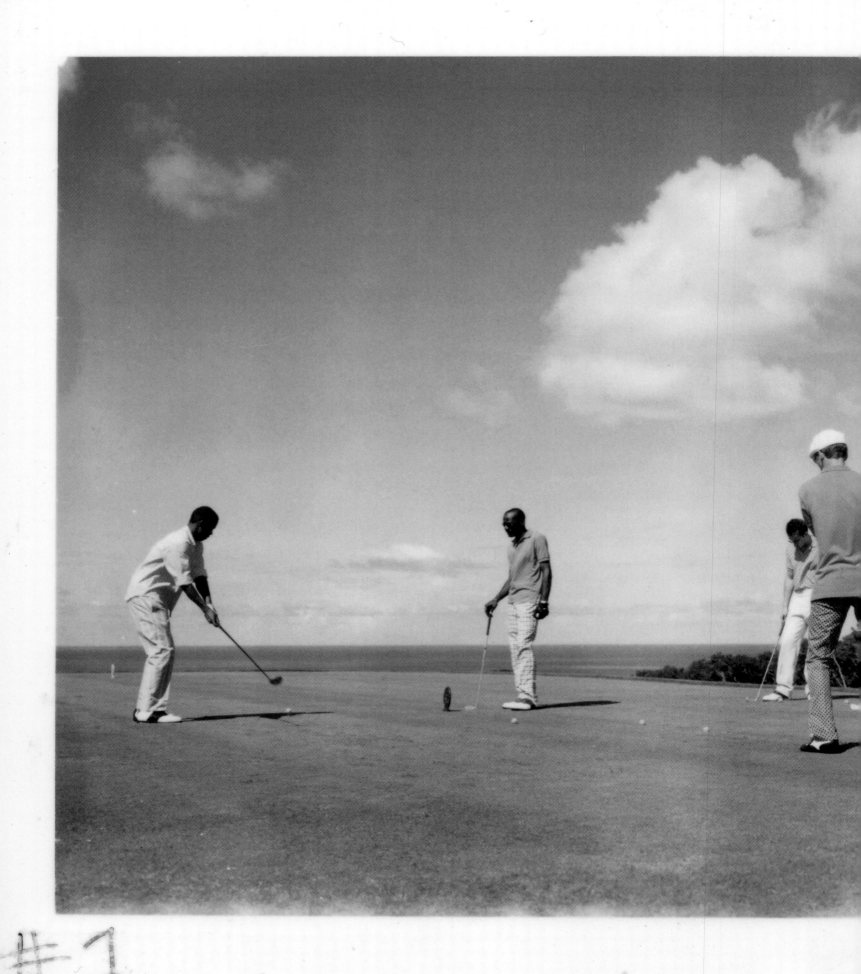

\#1

Jo: Tiger Tops is unbelievably beautiful, it really is, but it's a grassroots kind of place. First I had to negotiate crossing the river in a canoe with all the trunks of clothes for the shoot. As we got out into the middle it felt like a thousand hippo heads popped up all around us, and a thousand more crocodile bodies slid into the water in our wake. At reception I had to sign a contract stating that Tiger Tops would not be responsible for my death if I got eaten by a tiger. "Not if the hippos and crocodiles get me first" I thought.

Dana: So when Jo called to invite me to shoot two stories in Barbados it seemed very tame by comparison.

Jo: It was the reopening of the Sandy Lane Hotel, and they invited us to do a beach shoot and stay at the hotel for free. We added on the golfing story just to make sure that, post-refurbishment, Sandy Lane had got everything... you know... up to speed. Customer satisfaction is so important don't you think...we felt a responsibility to let them know if anything had fallen below par.

Dana: Initially we drove around the island, scouting the golf courses for possible models, but instead meeting lots of red nosed Englishmen, who were all golfers and quite an unattractive bunch. We were not happy. Until we spotted their charismatic caddies, who were all young, fit and looked like a Raging Fyah lineup. They were just what we were looking for.

Jo: Golf is one of the most popular sports in the world, and a golf course is the most wonderful canvas for colour. Golf clothes can be a bit boring and so I selected plain, bright colours that would pop against the green.

Dana: I use my Wista 4x5 field camera for all my work and have a special back for the polaroids. I generally start shooting on film before making a test, sometimes the best moments are at the beginning of a shoot, and then I make a polaroid, to check on the lighting and composition. Laying them out physically enables me to see what direction we're going in – or not - and whether I need to correct positioning and so on. When shooting film you have to wait till it's processed to view the results. When travelling that means this can take weeks. With digital photography it would drive me crazy when everyone is crowded round a laptop screen, scrutinizing the material while the shoot is happening. It would impact my concentration. I'm generally reluctant to work with professional models for fashion shoots, and prefer real people because they have a naturalness – and sometimes an awkwardness - on film which models will never give you. Although this shoot differs slightly as there is more line and composition in it due to the nature of the setting, a little less portrait based than usual.

Jo: When I work with Dana we never focus on the clothes, the people and their story come first. The two of us have an alternative scenario, like an unspoken script, that we stick to.

Dana: That's right, I don't talk much when I'm shooting so Jo was always the 'ego fluffer', making sure our subjects were comfortable and relaxed. What the polaroids brought to the process was the talking point, what they also gave to the process was the talking point between us and the sitter to make them feel secure about what was going on, though sometimes I preferred not showing them to the subject. It's a shame that no one makes the peel polaroids anymore. First Polaroids quit and then Fuji stopped making instant film. Production of medium format instant film by Fuji lasted a little longer and I stocked up on it. I have to guard my stash and use it wisely. I really miss the 4x5 polaroids now, terribly! Sometimes what came out on polaroid was the perfect shot, and you would always think 'oh shit, I should have captured that moment on film!'

David LaChapelle

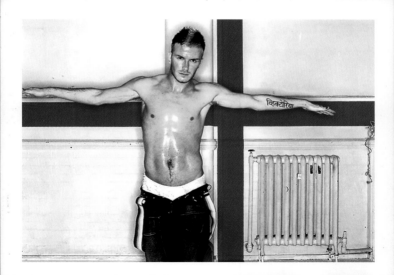

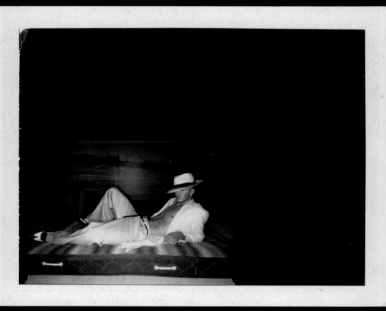

PHOTOGRAPHER: DAVID LACHAPELLE
DATE: JUNE 2002
STORY: DAVID BECKHAM

Jo: The FIFA World Cup was scheduled for the same month in 2002 so naturally David Beckham had to be on the front cover for the June issue of GQ. David Furnish was writing the feature. Mario Testino was booked as photographer, but had been forced to cancel at the last minute and in despair I called Elton John. "Well who would you like to have instead?" he asked. "If I could choose anyone in the world it would be David LaChapelle" I replied without thinking. "Leave it to me" said Elton, and within half an hour he'd rung back. "Of course he'll do it, just send over the details." I was amazed – another incredible opportunity for me, and surrounded by Davids into the bargain. We flew up to Manchester United. David LaChappelle and I met up for the first time the day before at the studio. The crew and I were being very

British, drinking our cups of builder's tea except for David, who was eating hummus. No one had heard of hummus in those days, we thought it looked absolutely dangerous.

David LaChapelle: And I'm still eating it. Along with the rest of the world now.

Jo: David pulled a scrunched up ball of cloth from his bag. It turned out to be a very grubby t-shirt with a St George's cross on it, and was scored with cigarette burns. "What do you think of this as an idea?" he asked. I said I thought it was brilliant. Then I went next door to unpack the twenty trunks of clothes I'd brought. It was Tom Ford's first collection for Yves St Laurent, inspired by Bowie's Thin White Duke. I pulled out a pair of baggy white trousers and carefully hung David's t-shirt up next to them.

David LaChapelle: When I came in I was looking for that t-shirt. I wasn't quite sure if Jo had thrown it away or not.

Jo: David has an eerie capacity to create an entire universe and if the t-shirt was part of it of course I was going to use it. I remember all the sets were built from scratch, and music was playing at full blast, with David singing along to Mary J Blige's *Going Down*.

David LaChapelle: Yeah, we had a DJ. I also remember playing Tupac's *California Love*. It was really loud, but it was important to create the right atmosphere. And the louder it is the less the publicists can talk to you, which is great. You need to choreograph a shoot so the subject feels special and can buy into that rock star fantasy. I could see when Beckham walked out of the dressing room he was really feeling it, because he told the PRs to leave.

Jo: We had to cover Beckham in body oil and paint his nails black which we then scratched off. We put him in tiny little denim shorts and David had the idea to have him lift his arms up. 'Nailed to the England cross' is the iconic image we remember.

David LaChapelle: To me, Beckham was the first footballer that could be presented as a pin-up model or a rock star. Athletes are notoriously difficult to photograph – Mohammed Ali being the exception – because they don't understand the value of a photoshoot and their people can be difficult. Beckham was completely different; he had no hang ups about the risk of looking vain, and was comfortable with the notion of taking male beauty to the next level. He was such a great guy, so friendly, adored his family and was clearly having a really good time in his life. He brought three year old Brooklyn to the shoot and didn't take his eyes off him

Jo: I knew this was another memorable project. I grabbed the polaroids as soon as I could. They are from a very precious part of my huge collection.

David LaChapelle: Polaroids are handy analogue tools; before them we had to guess our way through the process. So when they were invented they helped a lot, and people were always saving them from the studio. When I started out I was doing weddings, travel photography, food – anything to pay the rent. Weddings

taught me how to work under pressure, travel taught how to size up locations in any kind of weather I learned about different types of photography music videos, portraits, fashion and fine art, which I love. My advice for young people is to learn the cr photography. When I was a kid you had to get portfolio together, tearsheets and everything. It's a different landscape with social media. So people have these great Instagram portfolios bu don't know how to print. I had six years of dark practice in black and white, followed by six yea colour print, so more than a decade of work darkrooms. I know the print process inside out.

Like models wanting to be actors, there's so technique in acting and if you want a long caree you have to have the training, you have to hav experience over years and years. The same go photography – pointing a cellphone ain't gonna adding a filter digitally ain't gonna do it. Creativel intuitive in my approach and what I'm interested in, stayed true to that. I don't want to keep repeating so I keep challenging myself and moving forward.

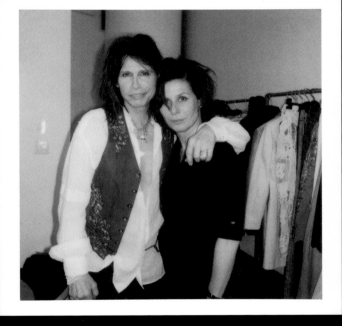

Steven Tyler

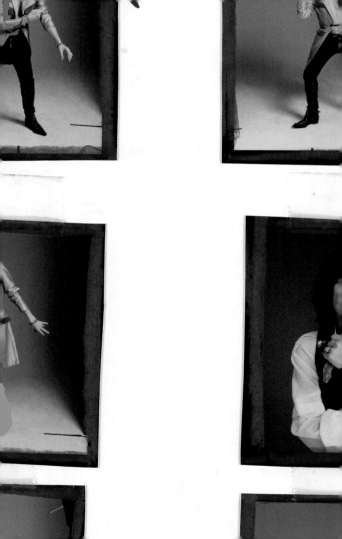

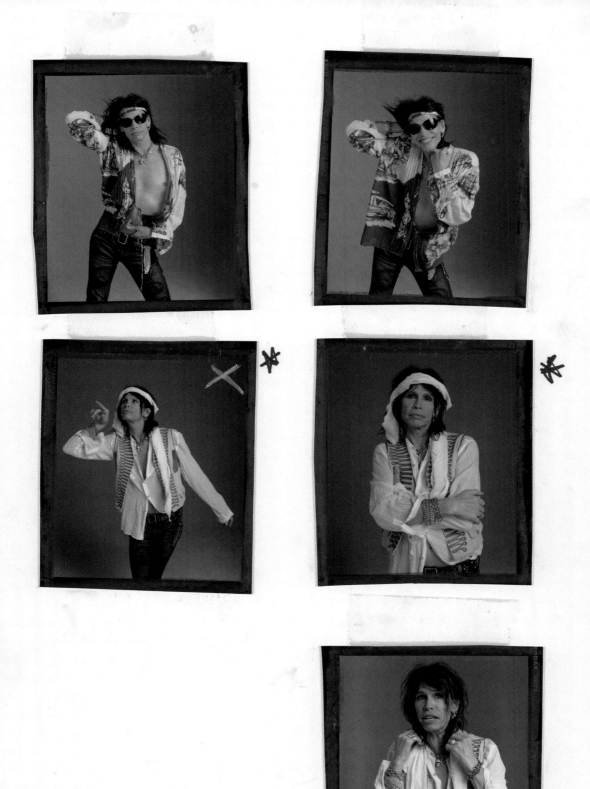

THESE
AS A
SERIES
5 ACROSS
A SPREAD
OR EVEN
A GATE
FOLD.

LIKE THE
KATE
NEF
TO ILLUSTRATE
MOVEMENT

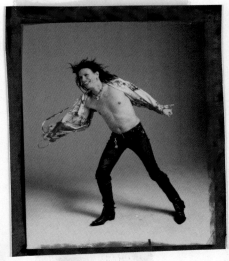

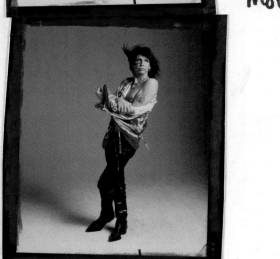

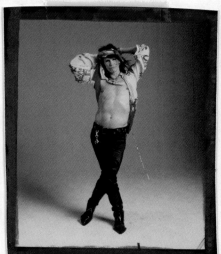

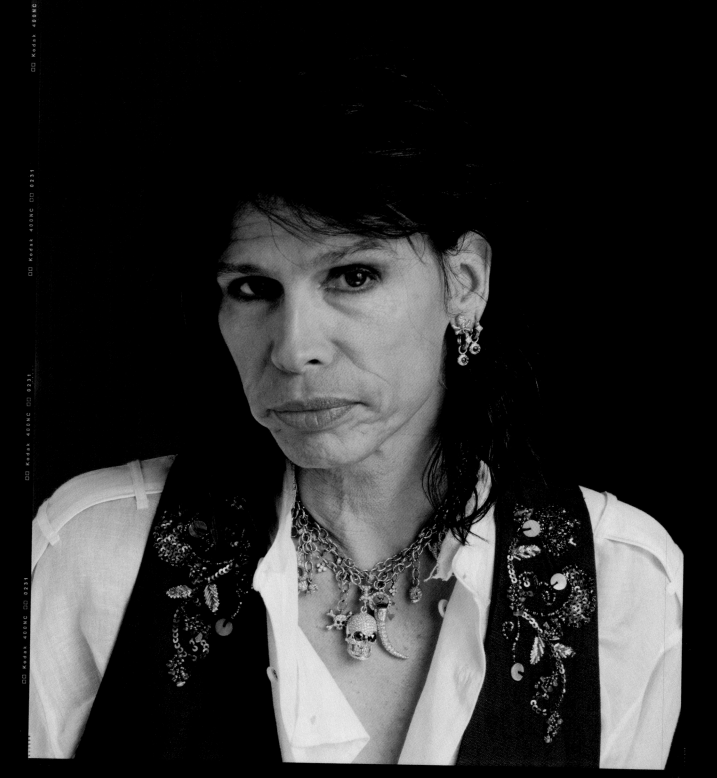

Gavin: I studied fashion but switched to photography at Central St Martins, where I was surrounded by some outstanding designers and collaborators: Antonio Berardi, Lee McQueen, Hussein Chalayan and Giles Deacon. I was able to photograph their work and collections, and was signed up by an agent so I didn't have to follow the traditional route of assisting. At the beginning the way I shot was was very reportage, predominantly black and white, as I was quite scared

moment, probably because of his early years photo backstage. He'd shot Steven Tyler once before and was already a relationship, which was vital, as once only had three hours of Steven's time.

Gavin: What I love about Jo is that she's an whirlwind. It doesn't matter who the star is, Jo come is fearless and says her thing. She has a knack of c

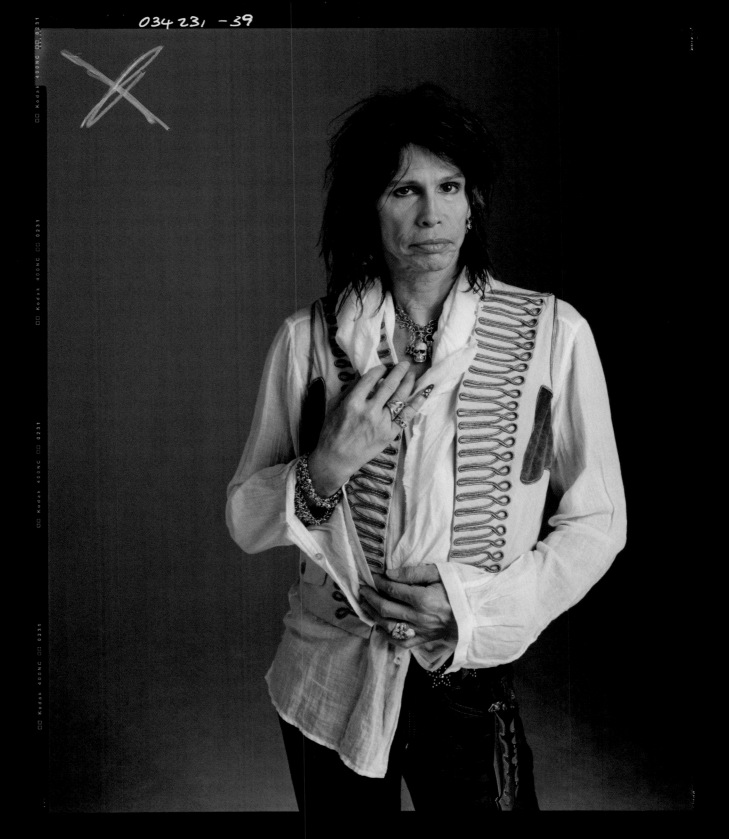

034 231 -39

Jo: To me, Steven Tyler embodies everything that is rock and roll, and I knew that Roberto Cavalli was one of his favourite designers. It so happened that Spring 2005's collection was perfect., because it referenced a swashbuckling, piratical look.

Gavin: If there's one thing Steven does really well in addition to singing that's move. We blasted the music and the fan and as always the showman came to life snaking across the studio floor. I don't know why but I was determined to shoot the portraits on 8 x 10 and 4 x 5 polaroid, which you see here, perhaps to create that sense of composure. For the movement pictures, I shot fast on RZ 67 medium format.

The polaroids formed part of the process, that magic three minutes you have to wait to see if you've got it right.

Some of these images have achieved large sums at auction, which is pleasing, so I'm glad that I wanted to shoot on film and not digitally, even though this was how everyone was doing it in 2005. Photography is now a big collector's item: I'm starting to go through my archive of negatives at Sotheby's request for their upcoming sales and an exhibition. I don't really like the immediacy of digital, and I don't approve of how photographers now film their subjects and pull stills from them. Where the craftsmanship and the mystery in that?

Julian Broad

Daniel Craig

PHOTOGRAPHER: JULIAN BROAD
DATE: JANUARY 2004
STORY: DANIEL CRAIG

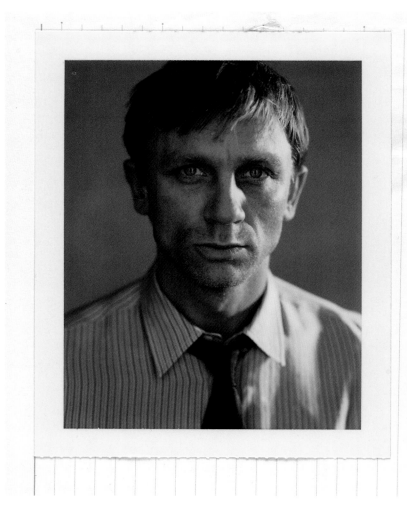

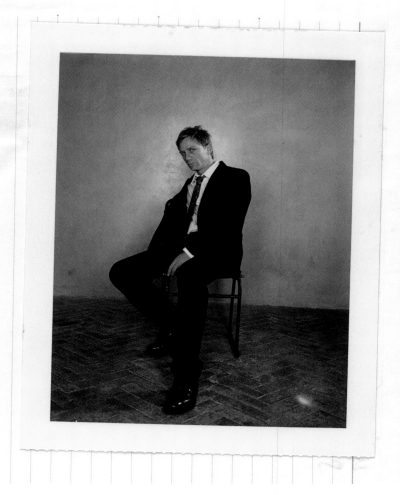

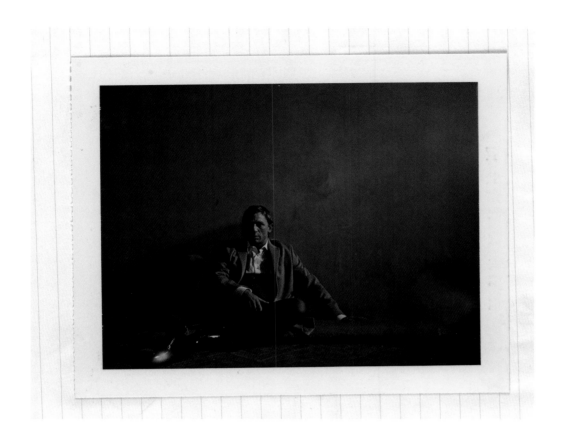

Daneil Craig – 1st Nov '3. Feb issue
photograph: Julian Broad.

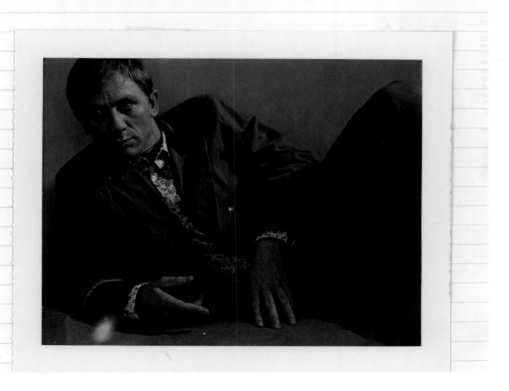

Julian: I think the shoot with Daniel was put together on the back of his doing publicity for the upcoming film *Sylvia*, about Sylvia Plath (played by Gwyneth Paltrow) with Daniel as Ted Hughes – good film actually.

Oliver Woods was the groomer and I still work with him today – in fact we are off in a minute to shoot the Orlebar Brown campaign.

Jo: Inspiration for this came to me in the middle of the night, and not because it was Daniel Craig... Sven Nykvist who was Ingmar Bergman's full time cinematographer, had made his first film, *The Ox*. I was fascinated by its overall mood, which was restrained and expressive. Nyquist shot in varying colours to reflect the protagonists' inner states

of mind. The film unfolds like the four seasons, ending with a spring-like scene of reconciliation. I particularly loved Nyquist's winter tones; the cold light, the blues and greys. As it was a particularly freezing January I thought this approach might work.

Julian: It was my first shoot with Daniel, and it was all shot on a 5x4 plate camera at a lovely studio owned by Zanna called the Ragged School. As Jo has pointed out, it was bitterly cold.

Jo: It was a first for all of us, Daniel although very used to having his picture taken, had never modelled clothes before. He was very shy and quite apprehensive and so I find it very useful to develop a specific mood, if not a

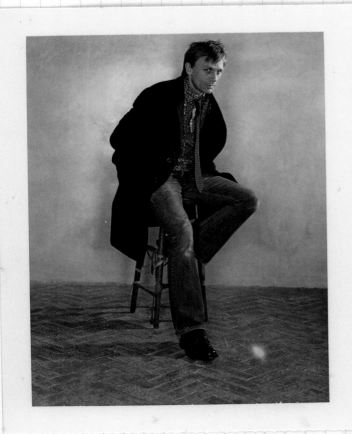
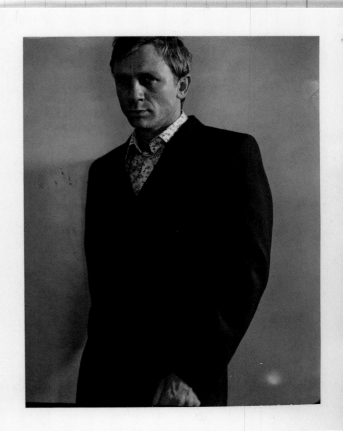

storyline when shooting an actor, to give them something to hold on to.

When we all arrived at the studio I told him I wanted to create a very painterly feel, a Nordic still life like *The Ox*, which he'd seen, so he understood what I meant. Unlike models, who wear more or less what they're told to, you need to make actors and musicians feel comfortable in the clothes they're going to wear. For example, Alan Rickman loved waistcoats so I made sure I always had plenty on the rails. With Daniel, when he arrived I talked him through the clothes, to put him at his ease with what he was going to put on. That's my job. When we saw the polaroids, I was very pleased to see this vision emerging, Julian had captured an incredible series of portraits with a very strong mood.

Julian: Seeing the polaroids develop was always very satisfying, but it could be a double-edged sword – by having an instant picture to show a client – you were generating a conversation – and an opinion ... Gone was the one to one between the photographer and subject – which was what Jo and I had with Daniel - now you had something that EVERYONE could discuss ...

Jo: But I think that's got worse with digital, don't you think, where the client can stand right behind you and ask for tweaks right there and then! There's nothing tangible to take away from a digital shoot.

Julian: Yes that's true. Also polaroids fade and I rather like that. It's a charmingly permanent impermanence.

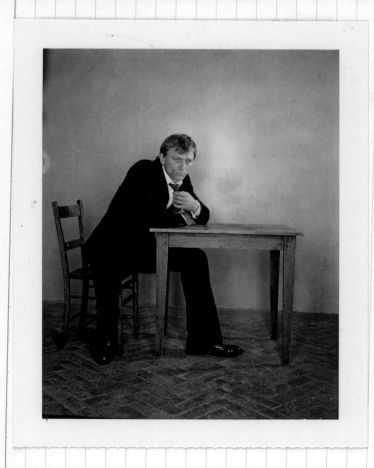

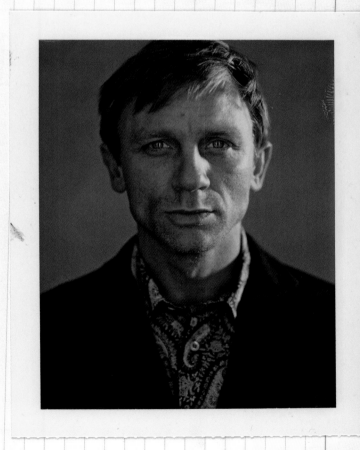

Guzman

Circus

PHOTOGRAPHER: GUZMAN (CONNIE HANSEN & RUSSELL PEACOCK)
DATE: NOVEMBER 2004
STORY: CIRCUS

Jo: On this occasion it was the clothes that inspired me. I'd been to Dover Street Market and found all these wonderful pieces with a distressed Versailles feel about them. There were some frock coats and ruffled shirts at Number Nine, the Japanese label, which brought to mind Deborah Turbeville's book *Unseen Versailles*. This is a classic book, published in 1982 by Doubleday when Jackie Onassis found out that 120 rooms at Versailles had never been restored or even unlocked. The results are haunting yet strangely magical.

Connie: Russell and I were also inspired by the French classic, *Les Enfants du Paradis* and the darkness of Grimm's fairytales. I remember throwing prop dirt all over the clothes to mess them up a bit.

Jo: I knew we didn't have the budget to go to Versailles itself so we chose the Rothschild House, Waddesdon Manor because it has the most amazing collection of 18th century sculptures in its historic gardens. The shoot was scheduled for November, and so the statues had been wrapped in canvas for the winter.

Connie: There was this eerie feeling when you looked at them, like shrouded sentinels about to pounce, and Jo came up with a further storyline for the models.

Jo: I'm obsessed with fairytales so I imagined that the statues were their princesses, frozen by a wicked witch.... and although Waddesdon had offered to uncover the statues, when we arrived they were much spookier left as they were.

Connie: The circus element evolved organically during the shoot. We were channelling the ideas of the menagerie at Versailles, and the masked balls held during the reign of the Sun King. I said "Alistair, we're gonna put you on stilts." I'm pretty sure he'd never been asked to do this on a job before, but there's a first time for everything. Scott had to balance about on the top of a wall, like a circus acrobat would, holding a parasol.

Jo: Once more we were lucky to have Scott Barnhill and Alistair who were the great models at the time, possibly because they were comfortable getting into character. Off they went, creating their own world, putting makeup on each other which created a layer of ambiguity – are they ghosts or are they clowns?

Connie: Again I think there's an ageless feel to this piece of work, and the many layers of the storyline and the classic backdrop give it that. I can look at this now and not feel it's dated at all. The surreal elements we added in still make me smile

GQ Style

November 16-17-2009

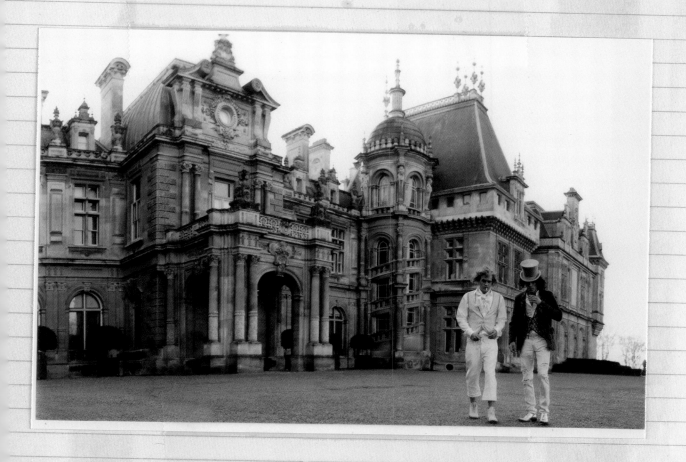

Alastair — White evening shirt Thomas Pink
Blue/white striped silk cutaway coat Number Nine
white cropped pants Louis Vuitton
cream canvas boots Dassault
cream silk scarf
cuff-links

Scott — Mauve damask cotton frock coat Number Nine
white silk shirt
white jeans (Down street "market
silver shoes Terre
Top hat loch.

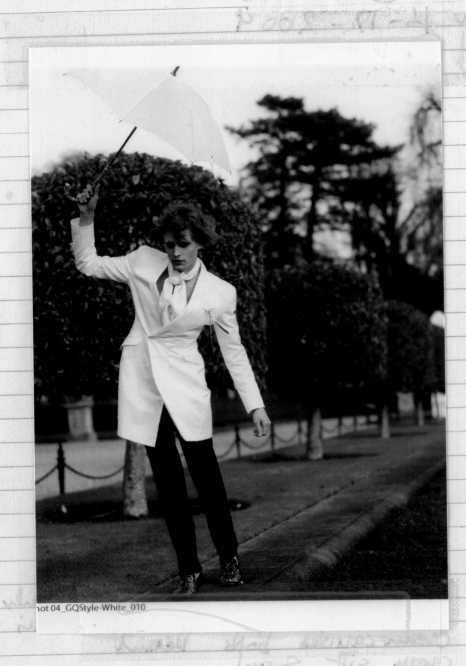

hot 04_GQStyle-White_010

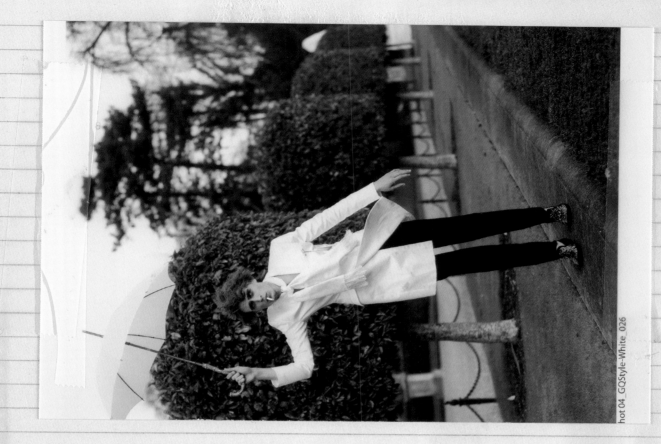

hot 04_GQStyle-White_026

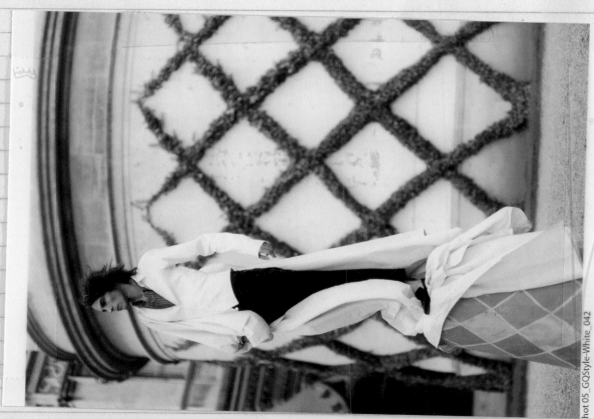

hot 05_GQStyle-White_042

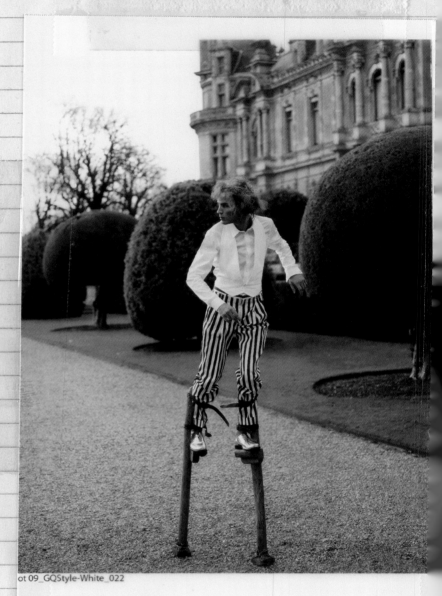

ot 09_GQStyle-White_022

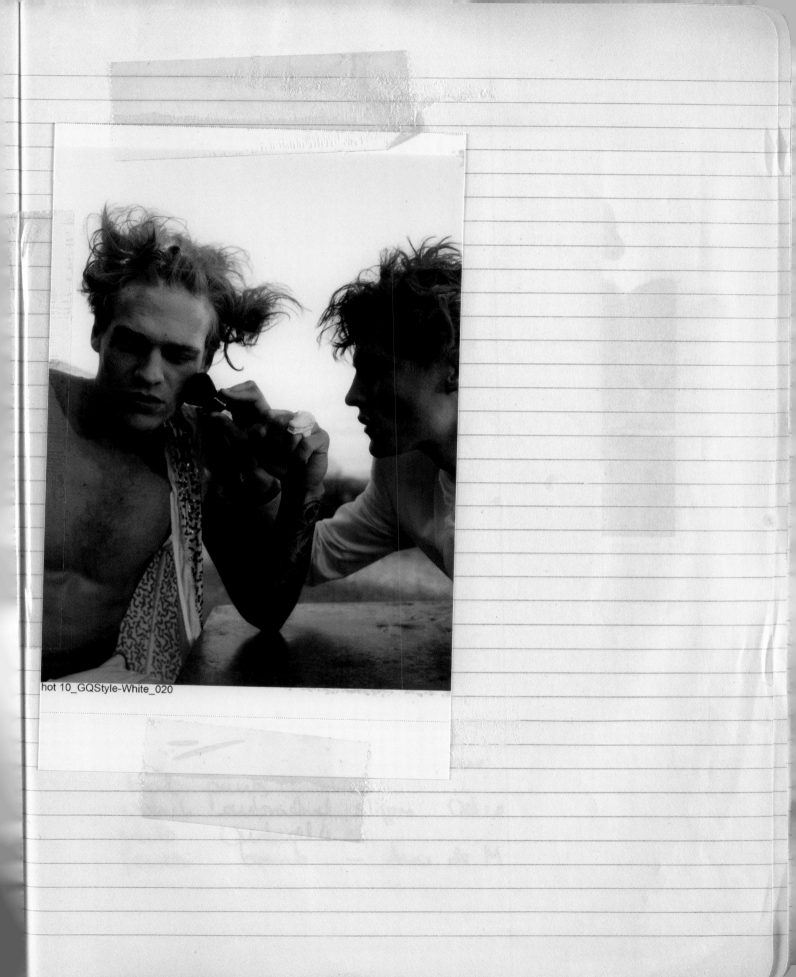

hot 10_GQStyle-White_020

Guzman

State of Grace

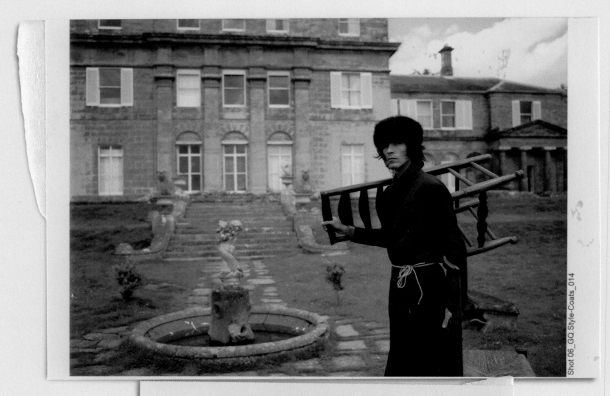

Shot 06_GQ Style-Coats_014

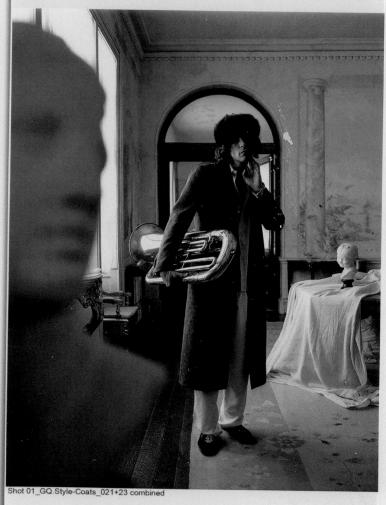

Shot 01_GQ.Style-Coats_021+23 combined

120

Guzman

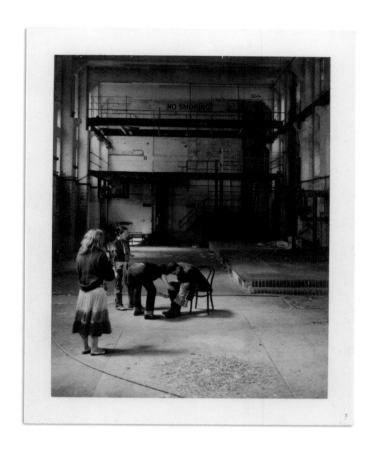

Revolution

PHOTOGRAPHER: GUZMAN (CONNIE HANSEN & RUSSELL PEACOCK)
DATE: MAY 2007
STORY: REVOLUTION

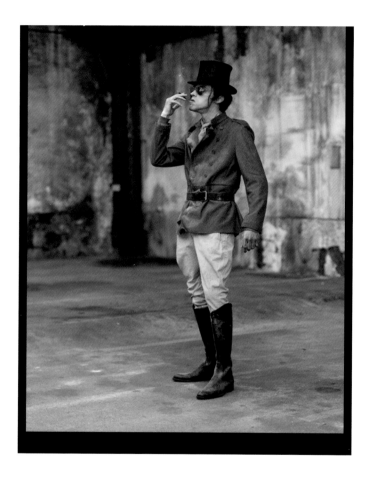 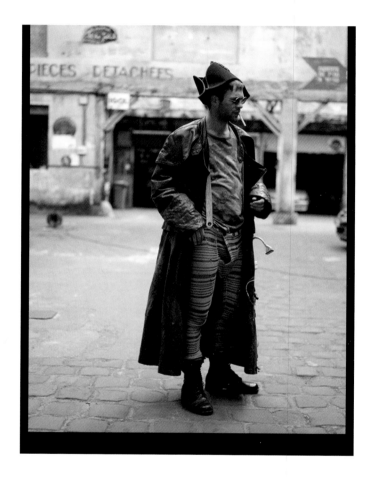

Jo: This is a good example of taking a subject – in this case revolution – and being able to expand the brief within it. With this theme, I could go a bit crazy on the clothes, and feature less well known designers whose talent I always wanted to promote.

So I thought about rebels and pirates and musketeers. And bad boys. I looked at the historical icons; Che Guevara, the Sans-Culottes of the French revolution, Jim Morrison and the Sixties counterculture. *Blade Runner* and *Mad Max* also came into it as the

epitome of Eighties anti-consumerism and global warming paranoia. Mix this all up and you hardly know where you are, which is a feeling I love.

Connie: I remember Jo was inspired by the leather coat Paul was wearing, with a tricorne. She hung all these bits and pieces off it, as if the character had been pillaging items for trophies. It reminded me of the House of Beauty and Culture in Dalston, a studio where artists and craftsmen turned the contents of what they found in skips into objets d'art.' I was imagining, as I shot, that these boys had

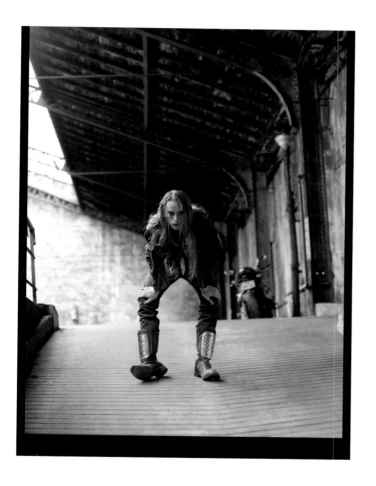

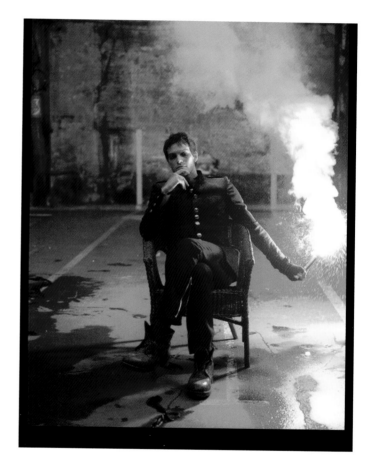

stumbled across all the clothes in a trunk, clothes that were leftovers from another time. These previous civilizations had been organized and normal, until for some reason they had broken down. The boys just put on what they liked, (luckily for the story they were 'naturally stylish'), and created a unique way of dressing that followed no rules.

Jo: We shot in Paris in a garage. Our set designer went out and found explosives and flares – which are very difficult and dangerous to hold – and burning flags. It was a bit nerve-wracking. I'm not sure you could get away

with that kind of pyromania now.

Connie: Our main concern was not to burn down the garage! Or send Jo back to the Conde Nast offices with her hair standing on end and covered in soot..

Jo: If I had, perhaps I would have felt I was carrying away that feeling of rebelliousness that I think we managed to capture on film. Possibly my colleagues back at the office might have just wondered what we had been up to this time.

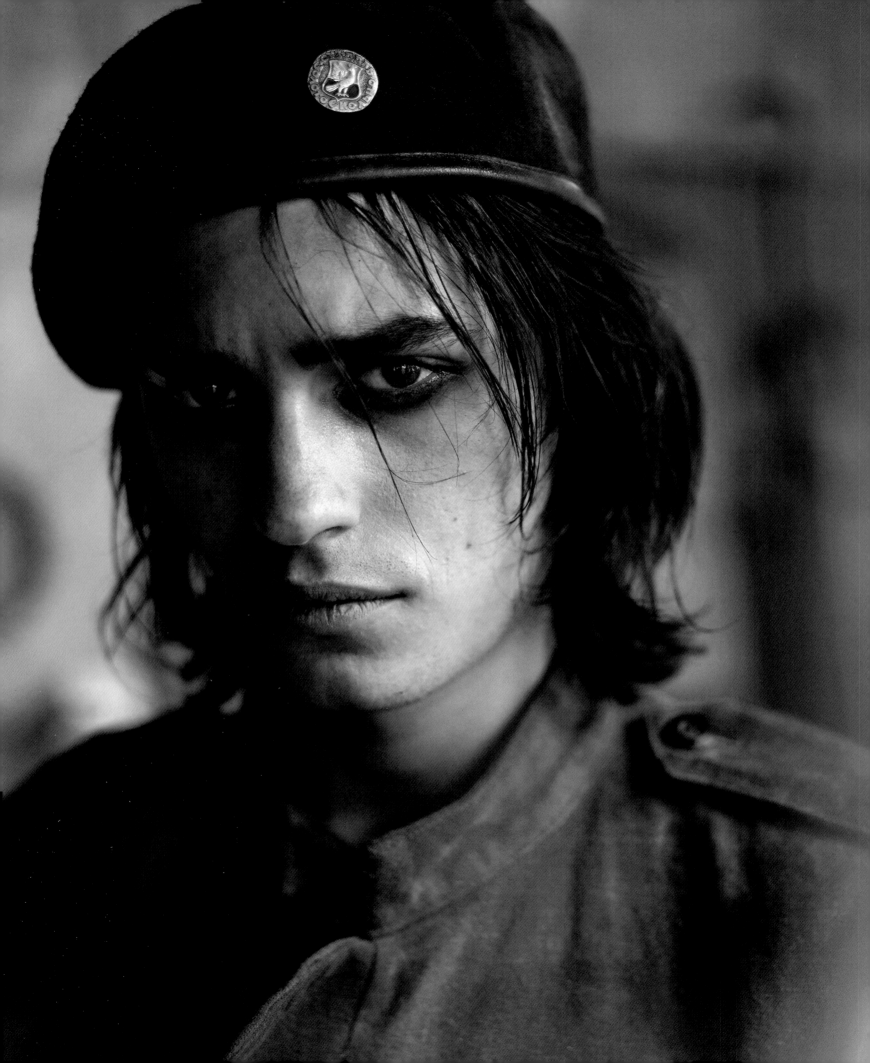

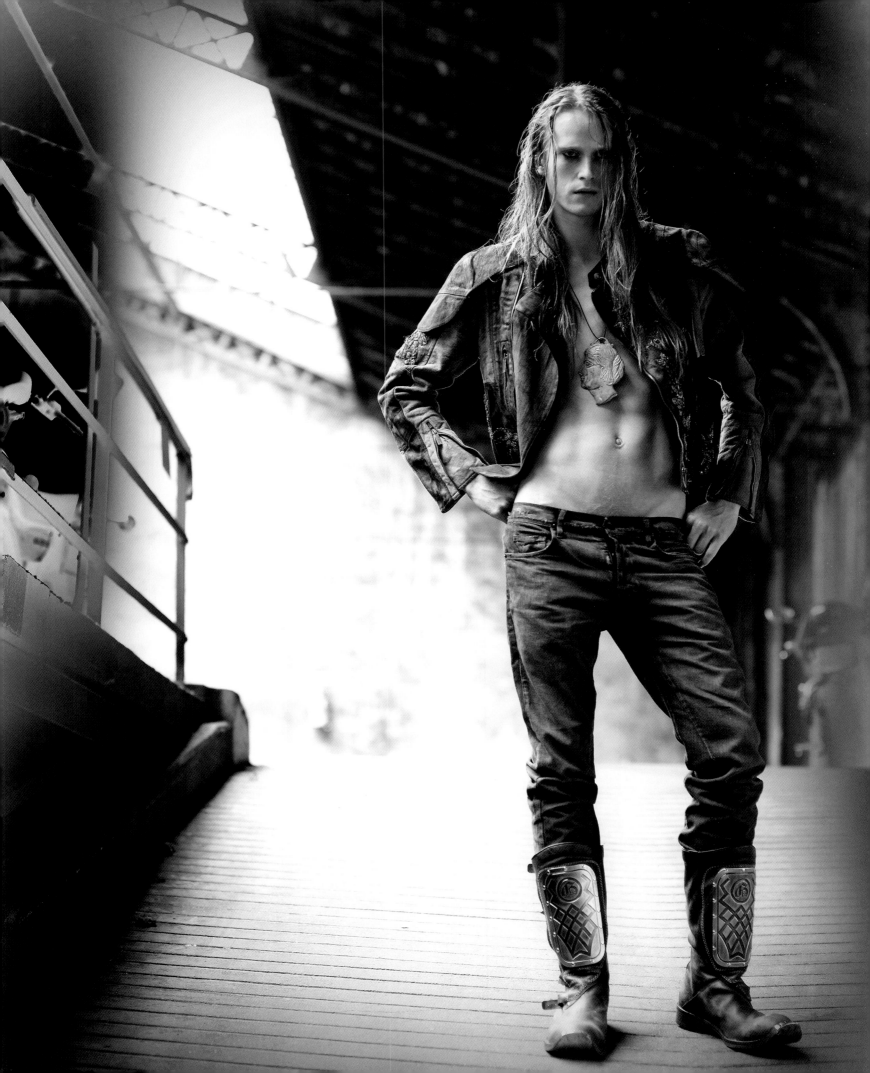

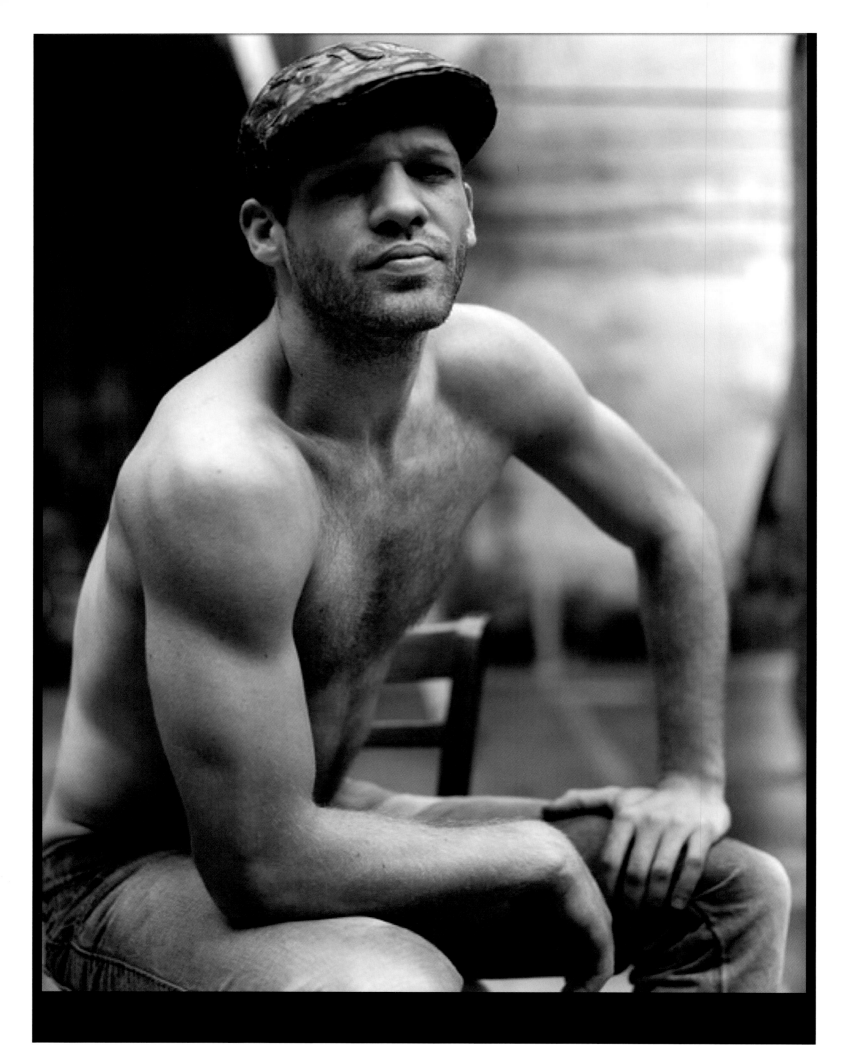

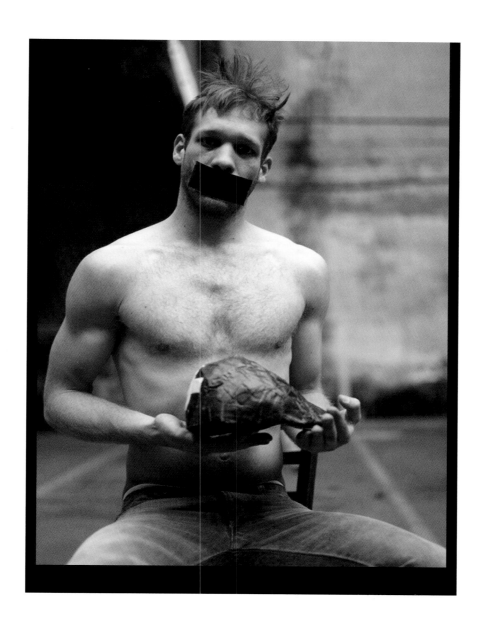

Guzman

England's Dreaming

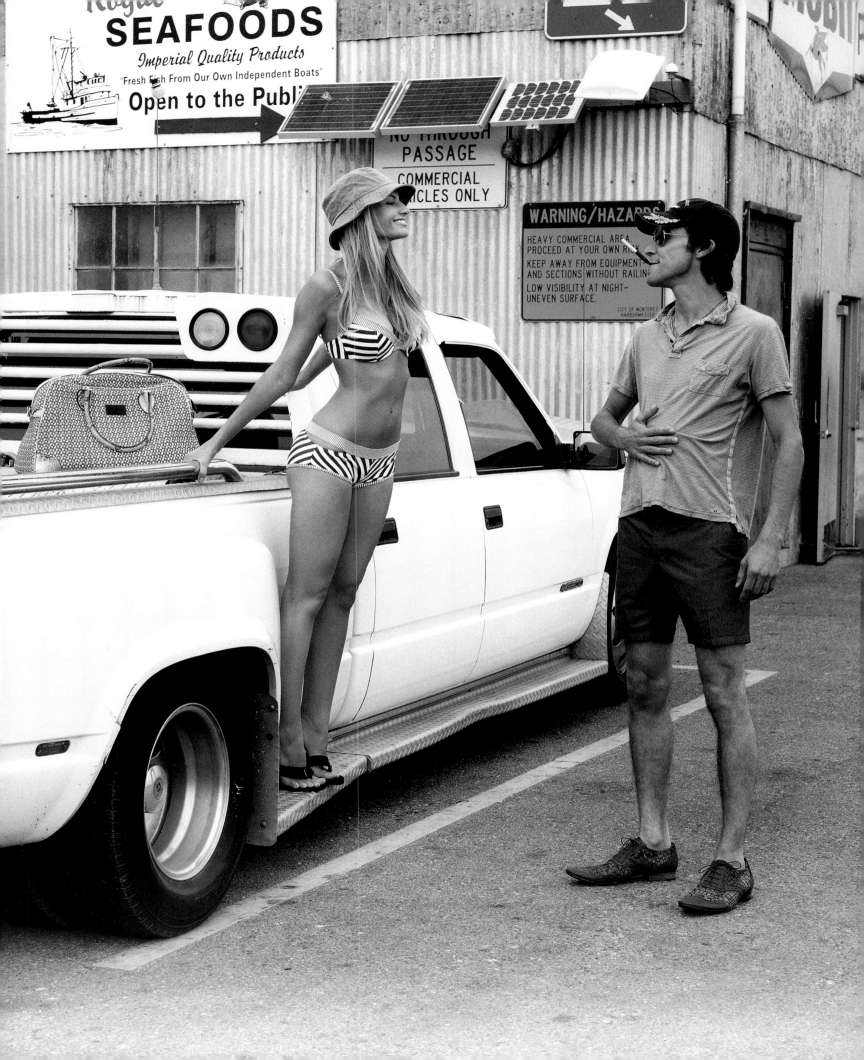

As with all these projects there are always too many people acknowledged and listed in these paragraphs so, as an imperfect 'catch all', I would like to thank all the wonderful photographers and associates with whom I have had the privilege to work and who have taught me so much and continue to do so.

Having said the above, a special thank you to Elton and David my dearest friends and collaborators who have supported me forever and in many ways, through thick and thin. Liz Jobey for introducing me to The Douglas Brothers (working with them was a turning point in my career and it is fitting they are the opening shoot in the book). Thank you to Suzy Menkes who has always mentored me and created the job of Style Editor for me on The Independent. Alex Shulman, thank you Alex for your perseverance in bringing me on to GQ. Andreas Reyneke for your, support, intuition and wise counsel and to my first brilliant assistant, Alexandra Kotur who, although living far away in New York, is still to this day a dear friend. A big thank you and tribute to the late, great Michael VerMeulen (Editor of GQ) who when I accepted the post as Fashion Director said, "Jo, if you turn the fashion pages around I will give you the world!" He did!

The team at Clearview Books sifted through a gargantuan number of polaroids and contact sheets from my collection, and my thanks to Catharine Snow and Rosanna Dickinson for their research and editing, and to Simonne Waud for overseeing the production of the book so beautifully.

Stephanie Nash and Anthony Michael at Michael Nash Associates, themselves powerhouses in the world of music and fashion, brought their superlative design and art direction skills to bear on the layouts, and a big thank you to them, Jonathan Carmichael and Jemima Hildick-Smith for this extraordinary work.

Lastly, I would like to thank my rock, my darling husband, Charlie for his constant support, guidance, wisdom & integrity.

Jo Hambro, December 2019

Index

Index